T0046489

DRAW YOUR WORLD

HOW TO SKETCH AND PAINT YOUR REMARKABLE LIFE

WATSON·GUPTILL

CALIFORNIA | NEW YORK

CONTENTS

DRAW YOUR WORLD

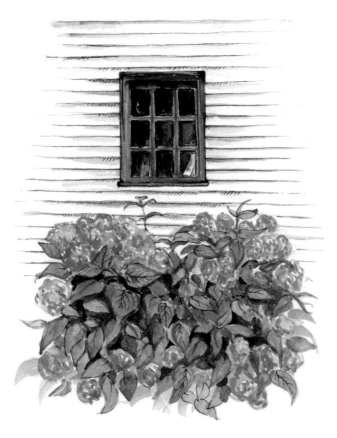

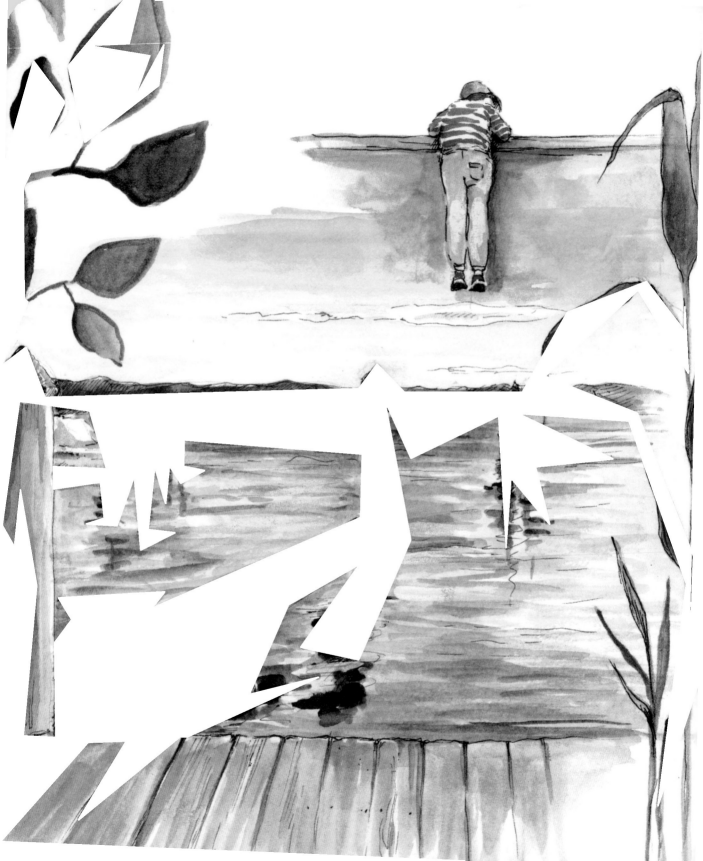

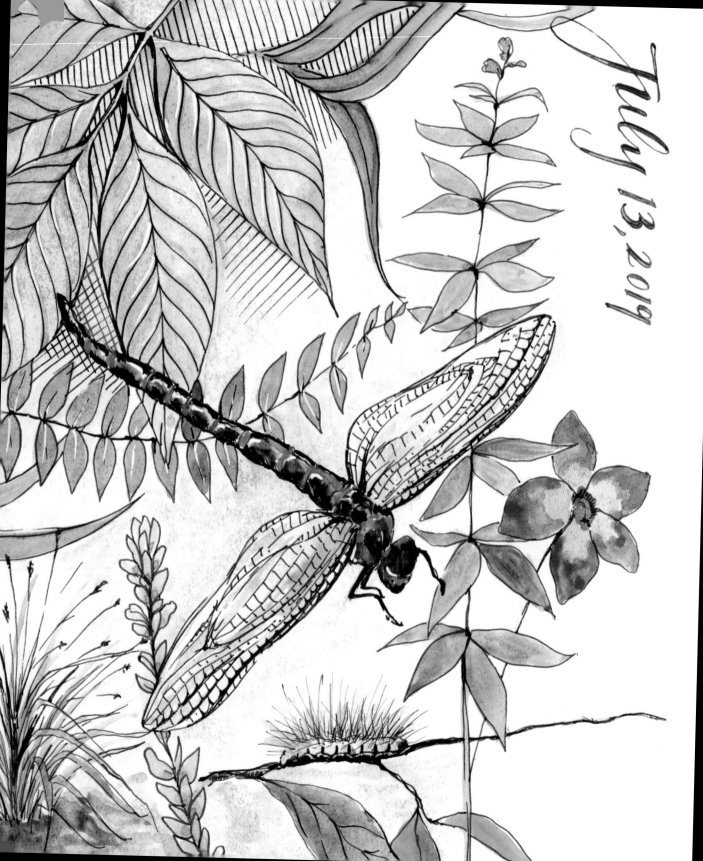
July 13, 2019

INTRODUCTION

I draw every day for at least an hour. The practice is not a burden or a chore but a necessary part of my daily routine, like brushing my teeth or exercising. I guess you could call it a compulsion at this point. Though I feel a need, there is also a deep desire that makes my drawing time a place I go to find peace and calm. In other words, drawing is my meditation. The practice fully represents life in all its ups and downs—sometimes it's fabulous and I am so pleased, other times the work is awful and I think I should close up shop for the day and try again the next. The quality of the work I create is dependent on my mood, the amount of sleep I got the night before, the news, the energy my children emit in our home, the confidence felt after a morning run, the insecurities experienced after an awkward conversation with a client, or the hugs I have received from my husband and kids. These feelings come to the surface through my pencil and pen. The practice is a constant reminder that my world is not perfect, that I must work through all of the good and the bad, and that great things can happen as a result of perseverance—and making mistakes. I am also reminded that just like in real life, I can forgive and forget, I can deal with any difficulty, and I can make something ugly into something beautiful.

Throughout my career as an illustrator and artist—terms I have only allowed myself to embrace in the past five years—I have made a consistent and conscious effort to stay true to myself. My work is not perfect, it is not created on an iPad or in Photoshop, and it is not "camera ready," so to speak. It is gritty and real—an interpretation of the world around me. I draw my world in my way—and I love to encourage others to do the same. I don't make up fantasies when I draw but rather I draw the people and things right in front of me. I find the challenge of translating something onto paper a literal everyday rite of passage.

Today it will be an apple; tomorrow, a building. The next day I will challenge myself a little more and draw my son. I'll drink water and coffee while I draw and then I'll draw that coffee and water. It's not so exciting when you think about it, is it? But on the bright side, when you draw what's right in front of you, there isn't any time for artist's block. In fact, I find it very rewarding to draw the same thing every day. And by doing so, each day I see that thing a little differently. The drawing of that same subject not only changes and evolves because of practice and skill but also alters depending on how free or tight my hand is— again, reflecting a direct relationship to the state of mind that comes with that day.

In Giovanni Civardi's *Figure Drawing, A Complete Guide*, he writes, "To be able to draw means, above all, to be able to 'see,' to understand rationally, to feel emotions, and to master the techniques which allow us to fully express our thoughts and moods." It is important to understand exactly what the term "mastering" means. It is a scary term for any artist because the idea of mastering something implies pursuing perfection. While I do believe that learning and practicing traditional techniques are very helpful when beginning a drawing practice, it is not about mastering these rules but mastering our own interpretation of them—owning our personal style. Arriving at an individual artistic style is a process that can take years. And once

It is only by drawing often, drawing everything, drawing incessantly, that one fine day you discover, to your surprise, that you have rendered something in its true character.

— CAMILLE PISSARRO

we think we have come to that happy place that represents us, we then strive for another level—it's a never-ending process and evolution. Early on in my drawing practice, I realized this reality, and it helped me greatly. We grow, we change, we always want more for ourselves, and therefore there will be a feeling of accomplishing that unattainable "mastery" only in small moments. As the world around us shows, we can go backward, then we go forward again.

In my previous book, *Draw Your Day*, I stressed the idea of drawing as meditation, relaxation, and a time to yourself—an opportunity to reflect on the details of your day: capturing your memories through a combination of writing and art making, intertwining the two, working your writing into the artwork on your journal pages. In *Draw Your World*, we go both wider and deeper. This book is not limited to journaling— any drawing, painting, or creative surface would work. You will still see some lettering and playful type in the artwork I share, but this time we will be focusing more on an art-making practice; whether you choose to incorporate words or not, anything goes. This book is designed to help you think about what to draw or paint and to teach the skills that can help get you there. If you are reading this book because you need motivation to create work, then my first bit of advice would be to purchase or pull off of your shelves a small sketchbook and put it in your bag or your jacket pocket, along with a pencil or pen of choice. If you have a sketchbook with you, you will always have the opportunity to sketch. You never know when that longed-for motivation will strike you. It might be on a subway ride or on a walk with your dog. Knowing that the sketchbook is there will also simply help you to see the world around you with a different lens. You will look for things to draw, and the intention is that eventually you will draw them. The more you look around you, the more you will notice details that may ignite that creative spark, and your sketchbook will be there for you.

It is important to understand, and I will emphasize this greatly throughout this book, the significance of the drawing process in relation to *seeing*. By drawing something, whether it be an object, a building, or a person, we see the subject in an entirely new way. Seeing something as you pass by it is very different from seeing something as you draw it. When you are drawing, you are seeing the world with different eyes, with a lens that gives you more understanding.

Let's take a simple coffee mug on your desk. You see it. You know it's gray and has a curved handle. You know it's round and comes in a bit on the sides. But if you were to draw that mug, you would suddenly see the reflections and shadows it creates on your desk as the light shines in from the window. You would notice that the handle has a little thumb

A TINY SKETCHBOOK IN A POCKET

LEARNING TO DRAW IS REALLY A MATTER OF LEARNING TO SEE — to see correctly — AND THAT MEANS A GOOD DEAL MORE THAN MERELY LOOKING WITH THE EYE.

—Kimon Nicolaïdes

dip at the top where it meets the side of the mug, and that the bottom curves in just a little bit before where it sits on the table. And so on. Suddenly, there are so many details about this mug! Drawing brings us to the present moment and allows us to observe things just as they are.

I am excited to teach you what I've learned in my years as an artist through lessons, trial and error, and persistence. After teaching hundreds of students in my workshops and dozens in one-on-one tutorials, I have come to realize that I do have a lot to offer, and *Draw Your World* is an opportunity to share it all with you. I will discuss drawing from life, from photo reference, and from memory, and how all three can be valid, beneficial, and essential to your artwork. I will remind you many times throughout this book that drawing is a muscle skill that anyone can learn through practice. If you can learn to write, you can learn to draw! In fact, writing is a variation of drawing—when we are children we train ourselves to draw the letters of the alphabet, and we practice writing each letterform over and over again until we can draw them without effort. Yes, it takes more time and patience to learn to draw a bowl of fruit just as it looks on your table, for example, but drawing your world is accessible to anyone compelled to translate the outside world onto a flat surface.

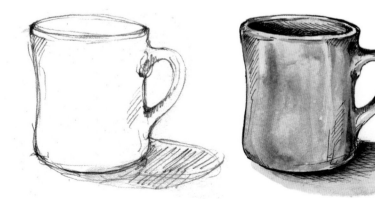

When we see our subjects clearly, or with new eyes, as we draw them, we can also decide in what way to translate them onto a surface. It's up to you to decide what this looks like. Maybe you see all of the nuances that you missed at first glance but you only want to capture some of them. Or maybe you want to exaggerate a certain detail. Making these decisions will help lead you to your own personal style. There will be sections in this book that will speak more to those of you who would prefer to draw literally, but some of you may want to skip to sections that are more about ideas, motivation, or collage and experimental drawing. I stress, again, that your creative practice is correct, valid, and wonderful in its uniqueness and that there is no right or wrong way to draw your world. Remember as you are reading through this book that I am not here to teach you the "right" way to draw, and my way might only spark inspiration as you find your own way. My goal is to share ideas that I have come up with and techniques that I have learned over the years to help people feel more inspired to make marks and drawings and achieve small daily or weekly victories. And to inspire a greater understanding of yourself and your whole world. In this book you will find chapters about tools and materials, continuous line drawing, light and shading, perspective, and composition. Then we will move on to subjects in nature; travel sketching; and prompts and ideas for keeping a travel journal; urban sketching; drawing from life, from photo reference, and from memory, and the benefits of all three; and experimental drawing and collage. Plus, fun drawing challenges and step-by-step skills are included throughout. I am extending an invitation to explore together: you can take in bits and pieces at a time, or read it through from beginning to end. When you get to the end, my hope is that you feel free and empowered to draw your world in your own beautiful and unique way.

Let's get Started!

TOOLS AND MATERIALS

If there are no rules to an art-making practice, there are also no rules on the correct tools to use. It is true what almost any section on materials will start with: *Getting better at drawing, however you choose to do it, is not about the tools but regular practice.* Anything from a Bic pen and a spiral-bound lined notebook to the most expensive tools on the market will work. I cannot stress this enough. That said, I have learned what works for me, and I am happy to share some of this knowledge with you. There are certain categories that I am able to speak about at length, but if you have an oil painting practice, or supplies in the closet that you would like to pull out, by all means, do so. I do not intend to make you feel pressure to spend a lot of money, though I have come to accept that a really high-quality paintbrush helps my work a lot more than a cheap plastic water brush will. And I have also learned that paper matters: If you intend to paint, paint on paper meant for paint. If you intend to draw in ink, work on paper with a smooth surface. I spent over four years working in a sketchbook made with paper not intended for the materials I used. I made it work, and liked that the books all lined up in a neat row on my shelf. After filling almost thirty-five of these books, a work colleague who represents one of the art supply brands that I use came to my studio and said, "Your work is worthy of better paper. I think it is time you reevaluate what this sketchbook is doing for you."

It is true that at a certain point the finished work you intend to do may be created with higher-quality materials, but the grit and practice that it takes to get there can be accomplished using lesser-quality materials. I now have a few sketchbooks on hand: a cheaper one that I throw in my bag for quick sketches, and a handmade one I use for my more treasured sketch journal. I keep lower-quality and higher-quality

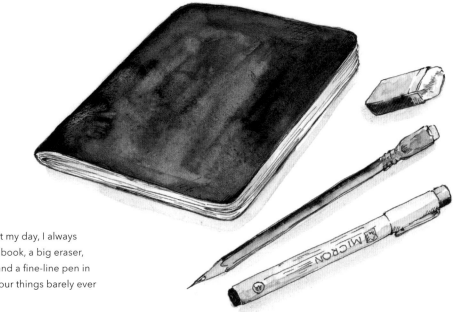

When I go about my day, I always throw my sketchbook, a big eraser, a sharp pencil, and a fine-line pen in my bag. These four things barely ever leave my side.

paper in my studio as well. I have small travel sets of watercolor paints that I take on trips with me, but my collection of handmade and extra-fine watercolors lives in my studio.

Materials are a personal choice, and there is so much to choose from. It can be overwhelming, so I am going to keep this simple: pencils; pens with archival, water-soluble ink; brushes; paint; water-soluble colored pencils and pastels; and paper. Plus a few other essentials at the end. If you decide to take a different route, or you already have materials you love working with, feel free to skim over this section. I prefer to keep it simple in my own life and for my own practice, so that is what I will share with you. Here we go!

PENCILS

The pencil was invented in 1564, and it really has not changed since. Pure graphite was made into rods that were inserted into wooden casings—pretty much the same process used today. It is rare for an object that was invented so long ago not to change—but that's because it hasn't needed to. The pencil is the ultimate tool, in my opinion. If I were asked to choose one drawing device to throw in my bag, it would be a pencil. You can do so much with a pencil, and you can correct mistakes with an eraser. I will lead you through pencil exercises a little later on (see page 28). What gets tricky is that, like most art supplies, there are so many to choose from: thicker pencils, thinner pencils, round barrels, the typical hexagonal barrel, flat carpenter pencils, triangular pencils, graphite alone with no wooden case, mechanical pencils, and more.

The best place to begin is knowing the pencil grading system and trying a few out. Pencils are inexpensive, so you can easily select a few to experiment with. Deciphering the pencil grading system is very simple. In the European system, H pencils are "hard," meaning there is less graphite left on the paper as you make your marks, therefore a lighter line. B pencils are softer or "bold," meaning there is more graphite left on the paper as you make your marks, therefore a darker line. A typical range is 10H, the hardest, to 10B, the boldest or blackest, with the HB pencil falling in the middle. The American system uses just numbers from 1 to 4, with the ubiquitous Number 2 equivalent to the well-known HB.

My preferred range is 4B to HB. And the pencils I use most are 2B and 3B. I find these give me the greatest range of dark to light. But as we'll discuss in warm-up drawing exercises, every hand is different. Some people have a harder grip and push down more on the paper and therefore may choose to go with a harder graphite. The harder you push and create grooves into the surface of the paper, the harder it will be to erase the marks completely. Go to the art supply shop and experiment,

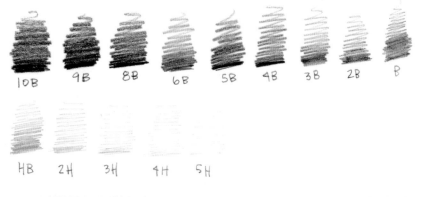

and find what you like best. As far as what I like best, I am a longtime fan of Blackwing, specifically their mixed or "balanced" graphite pencils. Blackwing does not follow the standard pencil grading system but instead has just four options (soft, firm, balanced, and extra firm). Blackwing Pearl, the balanced graphite, is my favorite. I also love Caran d'Ache's Swiss Wood pencil. There is a unique quality to this pencil that is hard to describe. It's a little heavier in the hand because of the wood it's made with, and the graphite is firm yet fluid. I use this one when I want to draw a little lighter and do not want to have to sharpen as often. It holds its point very well.

ERASERS

I always recommend having a large plastic eraser with you whenever you are working. Erasers on the top of pencils never work as well as a big stand-alone eraser. It is my opinion, after trying so many erasers, that plastic works better and is gentler on paper than rubber. You may have a favorite rubber eraser, so carry on with that if you are happy. As with so many other tools, it's a personal choice. There are many plastic options on the market, but my favorite is a Japanese eraser, called the Matomaru-Kun plastic eraser, that I buy from CW Pencil Enterprise. They sell it in a few sizes. If that is difficult to find, a Staedtler Mars plastic eraser is also a great option.

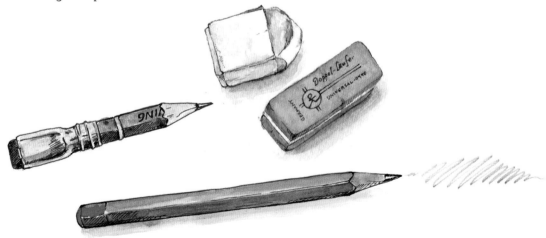

FINE-LINE PENS AND INK

Pens are very, very personal, and each person will have a favorite. *Permanent, archival, water-soluble*—these are the words to look for. I actually don't know why any fine-line pens do not use permanent ink, but many do not, and when you try to paint over your marks, it can be quite upsetting when the ink bleeds. But maybe you like that effect, and if so, that's cool, too. There are many options, and there are subtleties that really make a difference. The thickness of the nib (the part that comes in contact with the paper) varies, the nib itself can be firmer or softer, and some nibs split or bend if you have a harder touch. Some pens use ink that seeps into the paper, whereas others use ink that will sit more on the surface. Most brands will have a range of thicknesses, and the numbering system differs with each (unlike the consistent pencil grading system). Again, I recommend testing out many at the art supply shop. Almost all shops will allow you to experiment on scratch paper located right in the pen section. Get a few with thicker points (or nibs) and a few that are thinner so that you have a range on hand. Sometimes you will want to make darker, thicker lines, and other times you may want very, very thin strokes. I also recommend purchasing disposable pens that cost a bit less—Pigma Micron, Faber-Castell Pitt Artist, Pentel Arts, and Zig Millennium pens are reliable favorites—before investing in fancier options. If you decide you love working in ink, you can then look into pens that have metal nibs and casings that require the ink to be refilled and have many tiny parts, like a Rapidograph. Or you can even look into dip pens—the old-school pen-and-ink technique where you dip a metal nib that is split down the center and mounted in a holder into a bottle of india ink.

BRUSHES

I am only going to talk about watercolor brushes because that's what
I know best. It is a good idea to invest in a few good-quality pointed
brushes. In my opinion, a Winsor & Newton Series 7 in size 3 is optimal
for small illustrations. I have had two of them for about two years,
and they still work beautifully. These brushes are not cheap but are
worth the investment if you take care of them. They are handmade
with pure sable hair. There are many synthetic options on the market
as well, if you would like to spend a little less. Some artists prefer
synthetic brushes because of the amount of water the hairs hold. If
you are not sure and the choices seem overwhelming, it might be a
good idea to spend less at first and see what you think. If you already
have a seasoned practice, you may choose to purchase a few other
sizes depending on the finished size of the work you would like to
create. And perhaps a flat brush—which is cut flat at the top—or two for
making straight edges, creating a straight line, and pulling down with
a thicker stroke.

WATERCOLOR PAINT

If you are brand-new to a watercolor practice, then I highly recommend purchasing a beginner's set. There are many on the market. Some beginners prefer the Koi Field Sketch Boxes from Sakura of America; I used one of these for at least a year before graduating to a higher-quality set of paints. They are reasonably priced and have a range of bright colors. The boxes also include a waterbrush (a plastic brush that holds water in the handle that is released when you squeeze). Winsor & Newton makes many small sets, as do Van Gogh and Daniel Smith. In fact, since I began drawing again about six years ago, I believe the market for watercolors has grown significantly. It's hard to keep up!

Once you allow the floodgates to open, then purchasing watercolors can be extremely addictive. I often have to hold myself back from purchasing paints. The fact is, we all gravitate toward one family of colors more than others. I tend to devour my grays, blacks, indigos, greens, and, surprisingly, use a sky blue and a particular handmade pink all the time. But I love golds and browns, and I have a small family of colors that I use for skin tones.

I prefer to collect small pans of watercolors (bought individually in half or full sizes) and then fit them into metal boxes that I purchase separately. The little pans click into the holder, giving me the option of swapping colors out whenever I choose to. The small plastic pans can also be purchased empty so that they can be filled with tube watercolor paints—many artist-grade watercolors are sold in individual tubes containing a wet paint that you squeeze onto a palette (usually a plastic surface that allows you to mix or liquefy the colors easily with water). The beauty of watercolor is that once dried out, it can be reactivated by adding water. All solid watercolors are basically dried-out wet paint. It's important to note that once you begin to explore all of the watercolor paints on the market, there are many, many subtleties to each color. Some are made with purely natural ingredients from the earth, others

from artificial materials. Some have a more granular texture (as if there were grains of sand in the paint) and others are much smoother. Some colors are vibrant and more opaque, others very soft and more transparent. I tend to like paints that are more vibrant and richer and are almost opaque when reactivated.

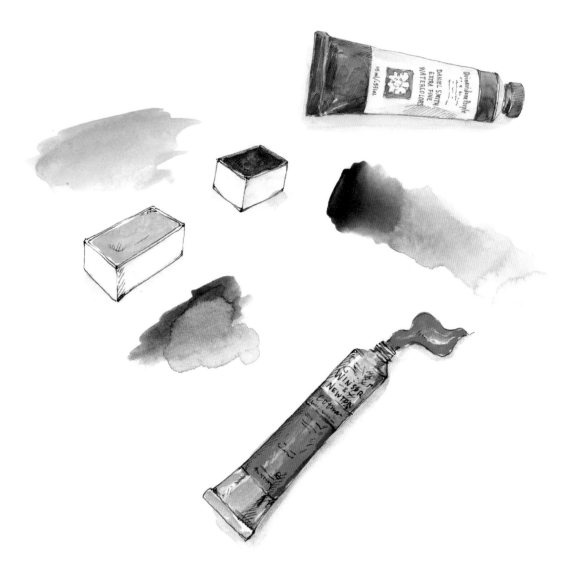

GOUACHE AND ACRYLIC GOUACHE

Speaking of opaque, there are a few other options for paint that are water soluble and perform similarly to watercolor yet have a very different finished look. Gouache, or opaque watercolor, is an excellent option to experiment with if you enjoy painting with watercolors. I often layer the two. I first paint with watercolor and then, once my shapes are established, I enhance or add highlights and depth with gouache. My favorite is the gouache pan palette from Caran d'Ache simply because it was given to me when I first began experimenting. I like the range of colors, and it is easier to pull out and use than having to squeeze a bit of each tube paint onto a palette. Whether or not I incorporate gouache into my work, I always have a white gouache on hand so that I can lighten areas and add highlights. Another alternative within the gouache family is an acrylic gouache blend from Holbein that is amazing to work with. These paints act just like gouache but once they dry cannot be reactivated with water. Therefore, you can paint right over them in layers without worrying about muddiness or mixing the color underneath with fresh paint. Similarly, I have recently been introduced to a line of water-based paints that dry permanently, from a company called Derwent. They are known for their "inktense" colored pencils that create an inklike wash when you add water. They have recently introduced these same pigments in solid paints, and they are wonderful. I love that a mistake can be covered, yet the paints perform similarly to watercolor, creating beautiful washes of vibrant color. They do dry fast, though, so I work quickly with them, knowing that once the paint is down, it's down.

WATER-SOLUBLE COLORED PENCILS AND PASTELS

I have been a loyal Caran d'Ache user since I was a little girl. I remember using Neocolor pastels and pencils in my grandmother's art studio when I was in grade school. They are tried and true, and I find them to be the perfect option in their family. The pastels are like a soft crayon, so you can play with pressure and create broad strokes. The pencils use the same pigments but with more binding so they can be sharpened to a point and create smaller lines. I love layering the two: the pastels for larger areas of color, and the pencils in areas of finer detail. Then, once you have the color down, you can add water and watch the pigments transform into gorgeous saturated colors. It's magical! Another bonus to using these materials for color is that you do not have to add water until you are ready. You can take a small box of pastels out on an adventure and add water later on, when you are home and can deal with brushes and water more easily.

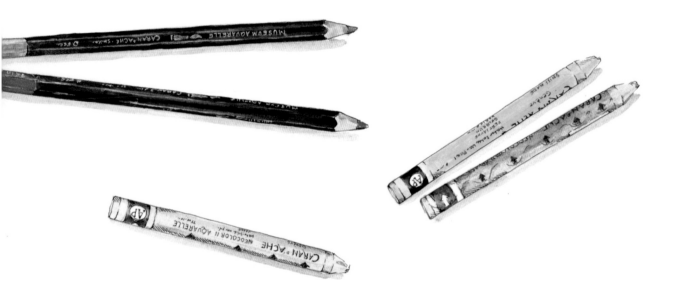

PAPER

I am not a paper guru by any stretch. My mother is a botanical illustrator, and I know each piece of paper she uses is an investment. I am too much of a mess for that kind of pressure. I have learned that like any other material you select, it's personal, and the nuances are subtle. It may take a few tries before you find a favorite. There are so many papers you can choose from, but we'll focus on watercolor papers because that's what I use most often. Cold-pressed versus hot-pressed watercolor paper is a pretty significant difference. Cold-pressed paper is more common because it has a bumpy or rough texture to it; the grain and fibers are looser so that the paint bleeds nicely into the surface. Hot-pressed has a smoother or flatter surface. Because I use ink, I much prefer hot-pressed papers. Watercolor paper is often sold in blocks, meaning that there is glue on all four sides of a stack of paper so that you do not have to worry about curling. Once you are finished with your work and the paint is fully dried, you peel the page off with a letter opener or other flat tool from the opening on one side. I use Arches hot-pressed watercolor blocks in my studio. And for quicker drawings that will be scanned right away, I love Fabriano hot-pressed watercolor paper, which is in a typical pad form with glue just at the top.

Caran d'Ache makes a few levels of water-soluble pencils. The Supracolor pencils, which are a bit less expensive and easier to find, use a slightly lesser-quality pigment. I also have some Museum Aquarelle, their "artist-grade" pencils, but can barely notice the difference in quality. Either option is a great choice.

SKETCHBOOKS

Finding good watercolor paper or a watercolor paper block is one thing. But the search for a good sketchbook that covers all of my requirements is a whole other beast that has been a topic of discussion with my followers and students for years. It has taken me almost seven years to realize that in order to have exactly what I want in a sketchbook, I have to make it myself. Why is it so hard? Well, it has most to do with paper, but also size and weight. I always say that my sketchbook has to be light and easy to carry (which usually means soft bound and not too large); square shaped or squarish; it has to contain paper that is durable enough to use paint, glue, or even tear and that can be worked on both sides without show-through; and ideally it has a pocket in the back to save old bits and pieces of found papers or notes. Because finding this perfect sketchbook has been so difficult, I began making my own using Arches hot-pressed watercolor paper. I realize that this is a difficult process and requires space and tools that not everyone has access to. If the idea of making a book scares you, do not worry, there are so many great sketchbooks on the market, and I have carefully selected a few in the Resources section (see page 163).

Other Essentials

Though they may not be absolutely necessary, I find it is really nice to have a few other things on hand at your desk or in your tool pouch. If you have them, you will find opportunities to use them, and that can only open up more creative possibilities. Some of these extras are:

• COLLAGE MATERIALS SUCH AS PIECES OF EPHEMERA, OLD STAMPS, COLORED TAPES OR WASHI TAPES, SCRAPS OF WRAPPING PAPER, OLD PHOTOGRAPHS, TICKET STUBS, PLAYBILLS, ETC.

• GLUE STICK • RULER OR STRAIGHTEDGE

• SCISSORS • SMALL PENCIL SHARPENER

• UTILITY KNIFE (AN X-ACTO IS A GREAT OPTION) FOR CUTTING SMALL PIECES OF PAPER

• WHITE GELLY ROLL PEN (FOR HIGHLIGHTS)

• OTHER FAVORITE PENS OR MARKERS

tside
shop in

dinner in the
strict at a Greek
t called MANDOLINE
thx to Irina

THE OLIVE
OIL BOTTLES
ON THE
TABLES &
LINED UP
OUTSIDE OF
THE REST RM.
←

noglii
WIRGIN
e Oil

ON THE BLOCK OF
THE ONE HOTEL

JU
LY 16
2019

MIAMI
BEACH FOR
20 HRS TO
PICK UP IAN!

PART 1
Technical Lessons

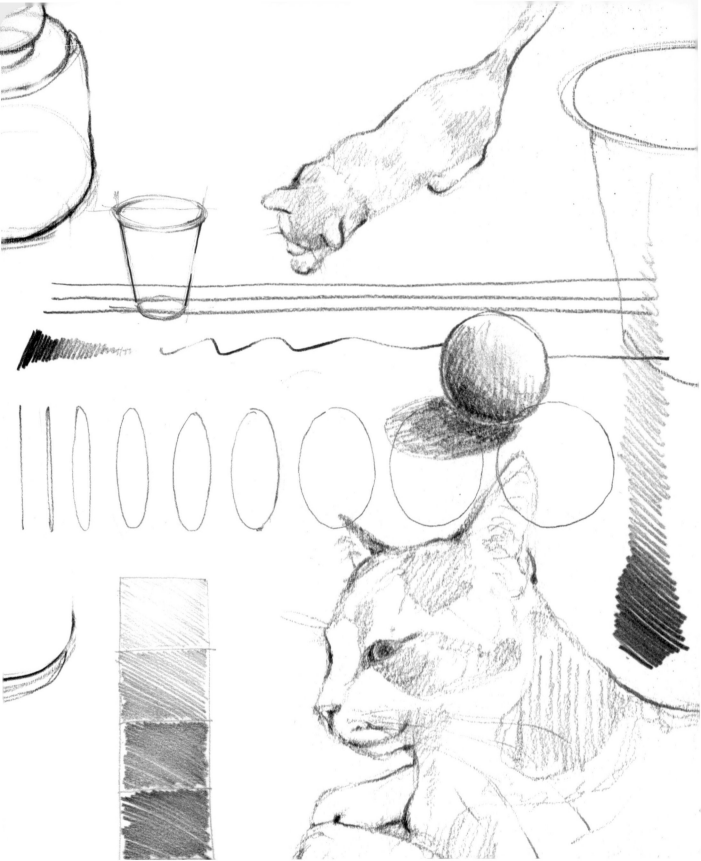

A DRAWING SESSION
FOR ALL LEVELS

Although most of my instructing hours have been group workshops and classes, one of my favorite things to do is teach students one-on-one. It's the only way to really connect and figure out what the person I am working with wants to achieve, to see what level they're at in their drawing practice, and to get a sense of how they see things. Do they have any experience with perspective, whether learned or innate? Do they have a certain flair that we should celebrate rather than overlook in the name of perfection? Well, this is almost always the case, but occasionally I will work with someone with a lot of technical skill who wants to work on getting to the next level. When we first meet, we get to know each other a little bit (feeling comfortable is as important for the student as it is for the teacher), and we sit right down and begin making marks with pencil. I always provide a Blackwing Pearl pencil, which is similar to a 2B or 3B; I believe this range is the best for drawing. (I discuss pencils in more detail starting on page 12.) I'll take you through my standard first lesson, starting with warm-up exercises that could also be done each time you sit down to draw or paint.

MAKING MARKS, LINES, AND CIRCLES

To begin, let's start with a very simple exercise. With your pencil, push and pull back from the surface of the paper as you make a single line—push very hard and very softly to see the difference in the lines left on the page. Draw these marks in patterns or scribbles; just simply make marks. This will show you just how much can be achieved with a pencil. From this simple exercise, observe everything from how you look at the page to the amount of space used on the paper; a lot can be gained by looking at these nuances. For example, when you explore marks on a page, did you use a lot of space or did you just make a few marks in the corner? I encourage you to be completely loose and free and make the lines flow across the page from edge to edge. It's liberating to just go for it—after all, pushing and pulling a pencil on and off the surface of a piece of paper should feel completely free of any story you've created about yourself as an artist. These are just marks and lines. Make them messy, make them fluid and carefree, close your eyes and see what happens.

Do you stay tight in a corner, or do you fill your whole page with marks and color?

Once you have made a page of random, loose pencil marks, the next step is to focus a bit more and work on straight lines and circles. A very effective way to approach straight lines and accurate arcs and curves is to make sure to use your whole arm in order to have more control. When you only work from the wrist, the lines will be crooked or arched. Using your whole arm also allows you to work a bit more quickly, and the quicker lines and arcs tend to be more accurate. Fill a whole page with straight lines. See what happens when you make your lines by using only your wrist, and repeat using your whole arm from the shoulder. Fill another page with circles of all sizes, and another with ellipses in various widths, some oriented vertically and others horizontally.

I like to think of these exercises as a warm-up. They help you to access and accept where you are in the moment. Are you more relaxed or are you stressed? Did you have too much coffee or are you extra sleepy? Drawing straight lines is like balance. Sometimes in yoga, for example, you might feel you could hold the tree pose for an hour, whereas other days you can barely hold the pose for twenty seconds. Some days you might find you can draw straight lines and almost perfect circles with no effort, and other days you will be surprised at how off-kilter each stroke is. No matter where you are at in a particular moment or day, working through these warm-up exercises can help to determine a game plan going forward. Maybe today isn't the day to work on that very small intricate pattern that requires a steady hand but rather is a better time to work in big, messy brushstrokes.

Your First Drawing

After ten to fifteen minutes of working on marks and lines, without any further preparation, I ask students to draw in pencil an object I have selected. I like to choose something perceived to be simple but that is actually quite complex, such as an apple or lemon, a jar, or a can of sparkling water. We'll refer to this initial drawing many times later on as we continue our lesson.

The most important thing to remember as you interpret your chosen subject on paper is that there is absolutely no wrong answer. It is as simple as this: In math class you must follow a formula and arrive at a correct answer, but when creating artwork there is no correct answer. Everything is valid and right, nothing is wrong. It's a matter of accepting what you have created. Whether this drawing makes you feel proud or embarrassed is up to you. No one is judging aside from you. And this is exactly what I tell students after they have completed their first drawing in a lesson or workshop. I celebrate every one of these drawings. What I do look for is the following, and you can think about these as you begin to make your drawing:

- Eyes on page vs. eyes on object. If you would like to draw your object literally, as close as possible to how it appears in front of you, then you must look at it very closely, as much as or more than you look at your page. (We will talk about this further as we get into blind contour and continuous line drawings on page 33.)

- Heavy-handedness. In an initial sketch, it's helpful to be as light as possible with your marks; this way you can easily erase. So be mindful of how much you press down. You might want to go with a harder graphite (an HB, 2H, or 3H) if it's difficult for you to make very light marks with a softer pencil.

- Basic form and style. A personal style shines through on this first drawing. Celebrate it and understand that what you have created is wonderful and an extension of you. Sure, you may want to home in on skills, but what shines through here are your individual quirks. You can then decide to push and pull a particular flair in order to establish a personal style as you simultaneously work on skill. After all, a unique style is the goal of any artist.

1 Find something you are familiar with, an object that you have seen over and over again. You could draw this object, or a character of this object, without seeing it in front of you.

2 Spend at least a minute, maybe two minutes, just looking at your subject. Look at all the parts of it. Notice how big one part is in relation to another. Look at where the lightest part is (or the highlights), and the darkest parts (or shadows).

3 Now draw it. Yes, just draw it. This is meant to be a carefree, rudimentary first drawing. You can use a pencil or a pen, or both. Use what feels right in the moment. Do not overthink it. Just draw.

Save this drawing. Do not toss it or tear it up. I challenge you to sit with it for a few minutes and then put it in a place where you can visit it again in a few weeks or months or even years.

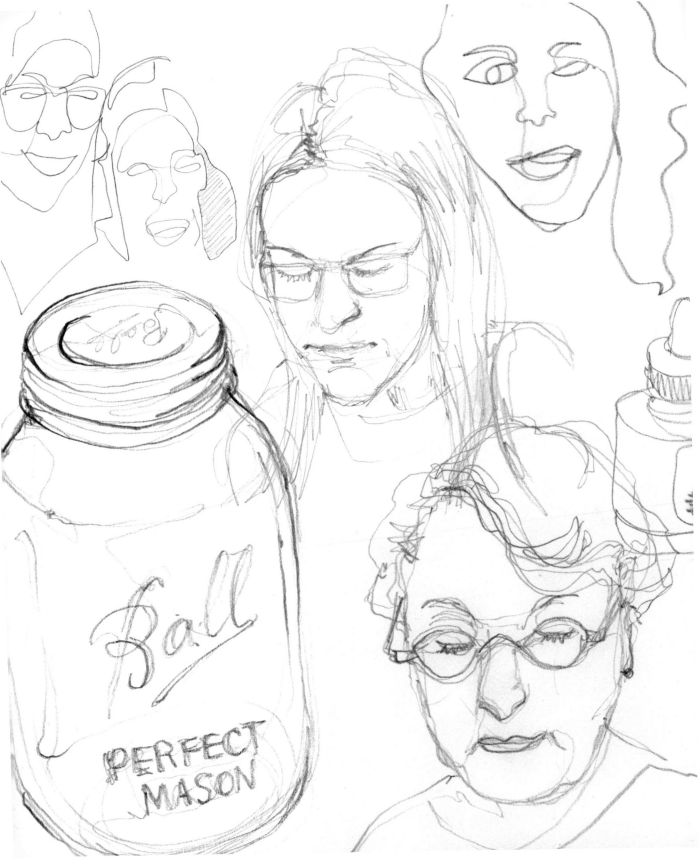

BLIND CONTOUR DRAWINGS AND CONTINUOUS LINE DRAWINGS

Whether you are new to drawing, coming back to it after a hiatus, or a regular, I find it's nice to go through the pencil-marking steps listed previously to see where you are today. Once you have had a moment to reflect and look at your various marks, along with your initial object drawing, let's explore making some pictures from a single line. Creating a drawing in this way enables you to really look at the object before you without focusing on or scrutinizing your mistakes. Your sole objective here is to observe, study, and truly see your subject. So without further ado, let's proceed.

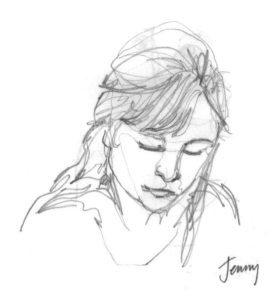

Jenny

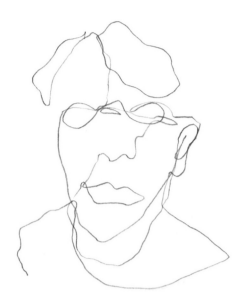

These portraits were drawn with one continuous, single line. I worked with light lines first and then added pressure once I was confident where the lines should be. It is beautiful to see all of the layers created.

WORKING WITH A SINGLE LINE

We're going to be working with blind contour line drawings and continuous line drawings. Both are made from one single line, created without lifting your pencil or pen from the page. The difference is that when making a blind contour drawing, you also don't look at your page. These drawings are almost always humbling, but you can clearly see and appreciate the beauty in them. And there is a lot of humor as well. When I teach a class, the room is filled with laughter when we work on blind contour drawings. What I like to do is have students draw each other. This is the best way to break the ice when you are next to someone you don't know, and to see that no matter how skilled an artist is, these drawings always level the playing field.

Once the laughter has subsided, it is useful to reflect on what you saw that you might not have noticed otherwise. When you are pushed to fixate on an object or a person, you will naturally see new things. For example, let's say you have made a blind contour drawing of a mason jar. You might have noticed a small detail, such as where the bottom meets the table, that you didn't notice before. Or the slight squareness to the center of the jar. I like to use an example of a Bic ballpoint pen. We know this pen well; we have seen it hundreds of times. You know it has a clear barrel with a black lid. You know it's cylindrical. But if you were to draw this pen just as it is, you would see small details that you never saw before: The cap has a small lip at the end of it, the cap is about one-fifth the length of the whole pen, the inside ink barrel is only filled with ink about halfway, and there are reflections the clear barrel makes on your desk as the light shines through it.

I absolutely love to experiment with continuous line drawings. I draw words and objects and faces this way in order to feel a sense of freedom and give myself a challenge. It feels similar to solving a puzzle. How can I get from one place to another on the page without drawing a line straight across the image? You have to carefully choose where to retrace your existing lines so as to enhance or add weight.

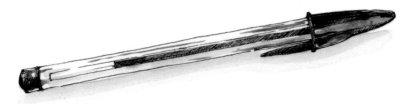

A Blind Contour Drawing and a Continuous Line Drawing of the Same Subject

For this challenge, select an object with a moderate amount of detail. The mason jar I mentioned is a good example because the overall form is simple but there are some words on the glass that can be fun to connect in one continuous line. A banana or a bottle of olive oil would also be interesting subjects. Or you could try to draw your hand. Use a pad of paper or sketchbook that you don't mind going through a few pages of (these drawings are not meant to be precious, though you might fall in love with them!), and be sure to situate yourself in a comfortable position a short distance from your subject.

Make sure that when you practice blind contour that the paper is not directly in front of you but off slightly to one side. That way it is more difficult to look down at your work while you are drawing. It is so tempting to look when you lose your spot on the page. But having one part of your subject in an entirely different part of your page than it was meant to be is what makes these drawings so freeing. So don't look!

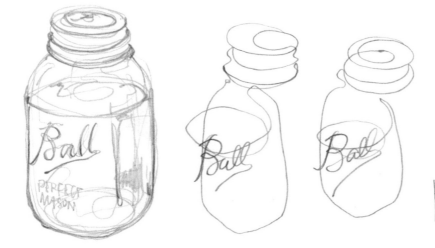

A continuous line drawing and two blind contour drawings of a Ball jar.

1. First, create a blind contour drawing. Do this without looking at your paper. Look only at your subject. It will feel almost impossible not to look down at your paper, but that is the beauty of these drawings—they are meant to be fun and awkward. Take thirty seconds to a minute on these—you will find that blind contour drawings are quicker because you are not looking at the paper, so it is actually better to move rapidly.

2. For the next drawing, without lifting your pencil from the paper but allowing yourself to once again look at the paper, create a continuous line drawing of your subject. Instead of lifting your pencil altogether, you will be tempted, try to just use very light pressure as you move your pencil from one place to another. Push down a little harder when you are more confident about where your lines are. Take two to three minutes on this first continuous line drawing.

3. Do as many of these as you please. You never know what the practice can lead to. In fact, you may decide to keep going with continuous line drawings in your finished artwork.

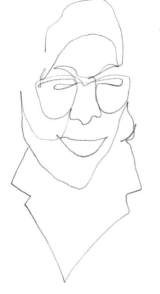

EXTRA CHALLENGE Do some blind contour drawings of a friend or family member. Blind contour portraits are so much fun if you are carefree about the process, and the portraits can be quite entertaining!

Everything we have discussed to this point—pencil line exercises; finding the right pencil for your touch and hand; warming up by working on lines, circles, and blind contour and continuous line drawings—should not take more than ten minutes. It is not essential to do all of these exercises each time you sit down to draw, but going through these motions sets the stage for the next phase of drawing. It is also okay if you don't have the time to complete all of them, or you can choose one or two exercises and spend two to three minutes on them. I like to think of this time as the equivalent of a very deep breath, or a stretch for the brain, to shift from whatever else you were doing previously to drawing time and "you" time.

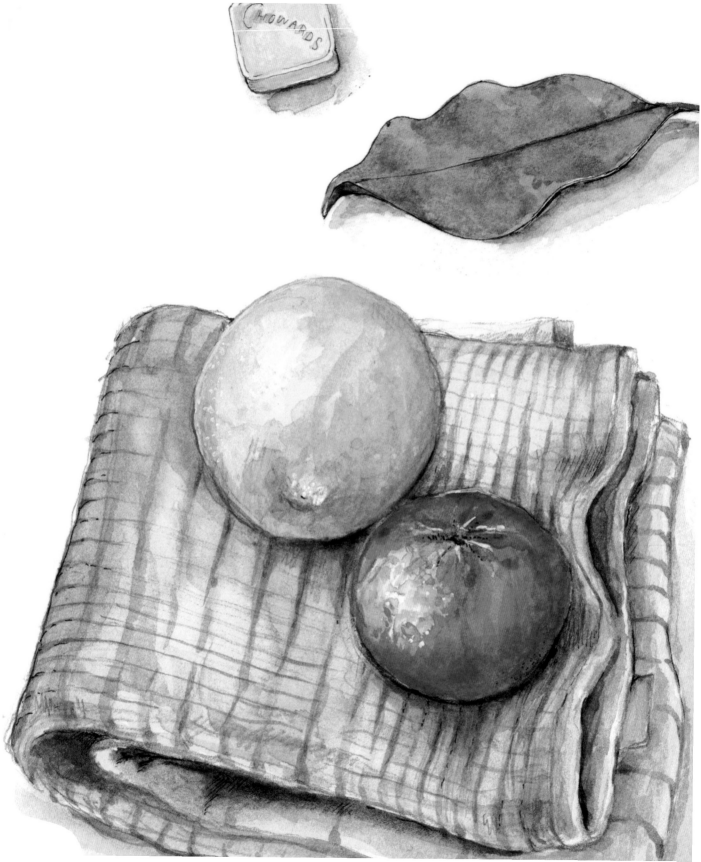

LIGHT AND SHADOW

If you would like your subject to come to life and to pop off your page, it is important to learn about light and shading. This is a complex subject that can be studied in depth, but I am going to give you a basic overview. A piece of fruit is a great place to start, as it is typically something that we are very familiar with; is usually round, so the shadows curve nicely around it; and is therefore a perfect subject with which to practice light and shading. It is a good idea to place your fruit on a white surface so that the shadows underneath are easy to see as you begin to study and experiment. As illustrated in the example on page 40, you will see that the dominant light source is coming from the top right. Note that where the light hits your fruit is going to be the lightest point, or the highlight. As the apple curves away from the light, your shading will get progressively darker until the surface is in complete darkness on the opposite side. The shadow will also fall away from the light. So if the light is coming from the upper left, the shadow will be to the right. A great way to see where the darkest and lightest areas are is to squint your eyes. Even when the subject is full of vibrant color, such as a red apple, squinting your eyes helps you to focus on the darkest and lightest places to translate onto your paper.

A Visual Breakdown of Light and Shadow

Light Source: The direction and location that the dominant light is coming from.

Highlight: The whitest or lightest point where light directly hits the surface of your subject.

Midtones: The range of moderate shading as the subject curves away from the light source.

Reflective Light: A subtle amount of light that bounces off a surface to create a slightly brighter area underneath the core shadow area.

Cast Shadow: The shadow that falls on the surface underneath your subject. It will be darkest closest to the subject and begin to get lighter as it falls away.

Core Shadow: The darkest part of the subject, where it is farthest away or completely hidden from light.

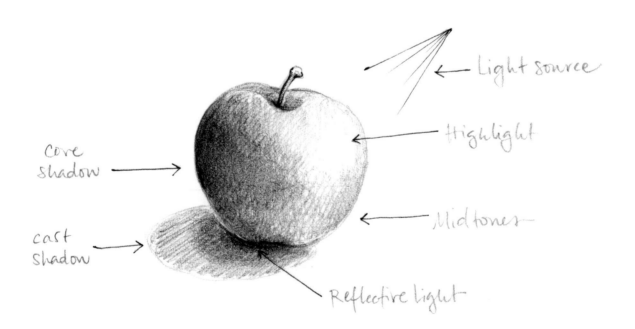

I am often asked how I create my shadows, or how my little drawings pop off the page. As you can see from the spot illustrations below, it's not very complex.

I simply painted the shadows in a very light gray wash consistently falling on the left side of each subject (the light source can be coming from any direction you choose). That way the collection looks like it's sitting on the same surface, with the same light source. It is important when painting or drawing shadows to have a very light touch, whether shading with pencil, shading in ink by crosshatching or stippling, or painting with watercolor. This way, once you have put down the lightest marks, you can then build layers closer in to the object where the shadow is darkest. Subtle shadows can really add a sense of dimension to even your loosest drawings.

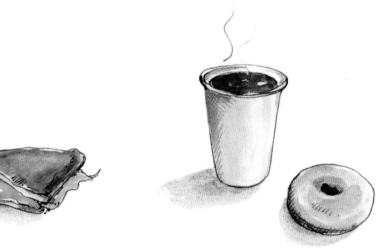

I often add just a touch of light gray wash to indicate a shadow. Shadows should fall on the same side of grouped objects for consistency.

Shading

This exercise will help you practice a range of tones, from the lightest to the darkest, using only your pencil. It doesn't matter which pencil you choose to work with; any graphite will be able to give you a range of tones based on your pressure. I do recommend a softer pencil if you have one; 2B or 3B is a good choice. But if you have only a standard Number 2, that will be just fine. Once you discover the range of tones that you can create with your pencil, you will then be able to create a greater range in your finished drawings.

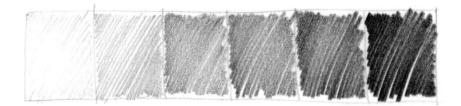

1 Begin by drawing a long horizontal rectangle. Divide it into six sections or boxes.

2 From left to right, fill each square, beginning with the lightest touch on the left and continuing to the blackest, heaviest touch on the right.

3 Repeat this exercise using a colored pencil or your pens. See how many ways you can go from lightest to darkest using various materials.

You may need to practice this challenge a few times in order to get it right. Some people have a heavier hand with their pencil, and therefore the lightest square may have to be revisited or added on at the left. Play around with it. You can fill your squares as perfectly as you would like to. I tend to stay a little loose, but some artists prefer to make their squares with a ruler and take their time, filling each square meticulously from edge to edge.

For this exercise it would be best to create a space for your subject to sit where you can comfortably study it, ideally under a desk lamp or in a spot that you can move a light source directly above and slightly to one side of. Prepare to spend a minute or two just looking. The more you look, the more you will see very subtle nuances that you may otherwise have missed at a quick glance.

1 Select a simple round fruit—a lemon, a peach, or an apple.

2 Place it on a light-colored surface with a direct light source. If your surface is dark, you can place your fruit on a white sheet of paper. As mentioned, a desk lamp is perfect for this exercise.

3 Really look at the subject and squint your eyes a little so you can see where the darkest shadows are—usually farthest from the light.

4 Begin with a light outline and then begin to experiment with all of the shades of gray to black that you made in the previous exercise by translating what you see in front of you onto paper—the fruit, light, and shadow. Gradually making your lightest marks blend into darker marks takes patience and practice. Spend a little time with this drawing.

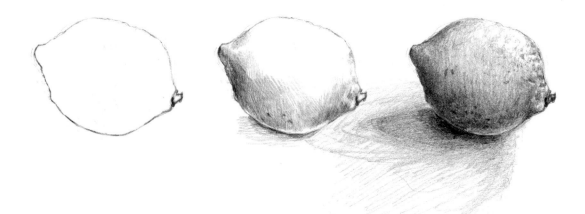

in "latte" color

BUT I HAVE TO WAIT 7-10 DAYS

→ NEW ROUND glasses

Boys all go
Skiing and to T's
Soccer tournament
and I stay in the city. A long
walk thru the LES and Soho before
I arrive at **see** for new glasses. I get some
Juice Press, head home on
MARCH 17, 2018 Subway, and watch 3 Billboards.
while drawing this entryway seen in Soho (or was it Elizabeth?)
Magnus Nilsson's cook book illustrations as I watch more Netflix

Sun
Clear s
SOLO D

SYMMETRY, PERSPECTIVE, AND PROPORTIONS

There are a few things to consider as you take on a new subject. I am not referring to style or materials but rather to basic rules of drawing: symmetry, perspective, and proportions. Because I have been drawing on and off since I was a little girl, some of these concepts I take for granted, as they have become second nature. But as I teach others, I realize more and more that each step requires explanation. Once I explain, there is often a look of "aha!" on people's faces. It all makes a lot of sense when broken down, and having a basic understanding of each step will not only help improve the accuracy of your drawing but will help you see the whole world differently.

SYMMETRY AND BALANCE

There are a few ways that symmetry is discussed and defined in art. What do the human body, an animal, a leaf, a flower, a butterfly, a piece of fruit, an automobile, and most architecture have in common? They are all symmetrical, meaning that there are identical parts that mirror each other side-to-side. When really scrutinized and approached in a technical and scientific way, no subject in nature is perfectly symmetrical, but for argument's sake let's say such balance exists. For example, the core of an apple and the stem fall in the center of the apple. Our noses are in the centers of our faces. Aside from the steering wheel, a car is symmetrical when looked at from the front. Drawing things with symmetry can be a challenge, as so often one element will be a little crooked or smaller than its mirrored other half. A ruler or your pencil-measuring technique (see page 58) can help greatly when you are trying to get one half to match the other half.

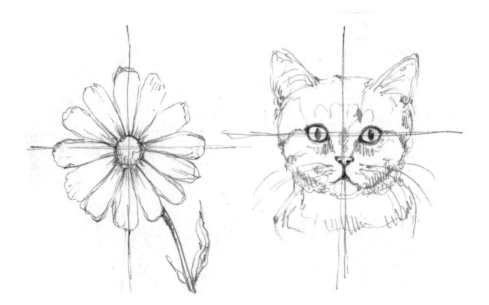

Symmetry also comes into play when you are planning a composition. Our eyes naturally want to see balance, so if you have heavily painted an area with yellow, it's nice to add yellow somewhere else on your page or surface for balance. Here we refer to symmetry as a sense of harmony and balance for the eyes. One of the greatest examples of symmetry in art is Leonardo da Vinci's *The Last Supper*. Jesus is in the center, and everything radiates from his figure. But symmetry in art does not only mean that something is in the center and everything is equal on both sides; it can also mean a balance of color or placement of objects so the eye can easily float across the work, taking it all in.

See the example to the right. This is a sample of one of my pieces that is not symmetrical but still exhibits a sense of balance in its composition. The woman at top left is looking down and there are pink details in her lips and bonnet. The lines then lead your eye farther down through the composition to the bottom pink line. There is a feeling of balance and symmetry even though top-to-bottom and side-to-side are not the same.

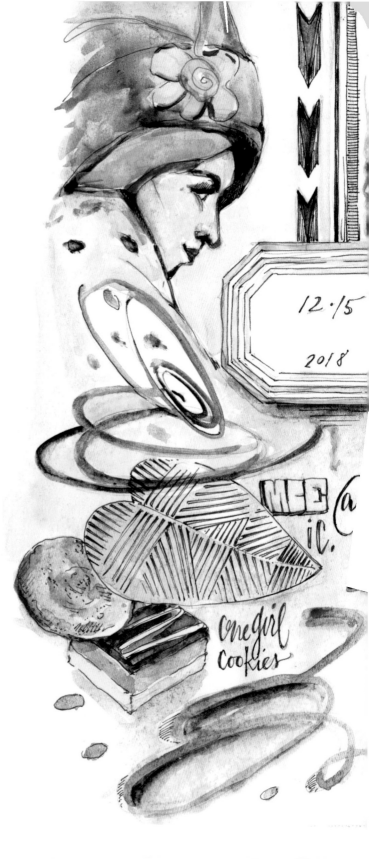

Symmetry

Here we will explore symmetry and balance in one piece of art. Select a subject that itself is symmetrical, a natural subject such as a piece of fruit or a man-made subject such as a shopping bag. Either will work fine for this exercise (I have selected a mailbox). Note that I have not placed my subject directly in the center of my composition; instead I've used something called the Rule of Thirds. I have done this intentionally so that I can build around it, adding balance and color throughout the piece. There is greenery surrounding the mailbox that I will use in other areas to help the eye float through the whole piece.

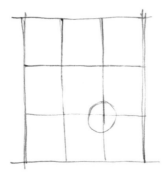

1 Place your subject in front of you so it is not on an angle—you are looking at it straight on. Look closely at the shapes you see within your subject, noting what falls directly in the center, to the left, to the right, and above and below.

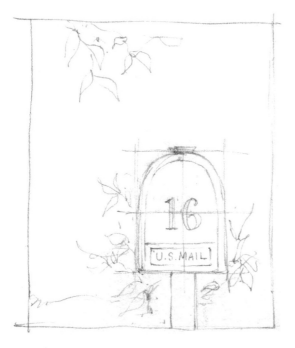

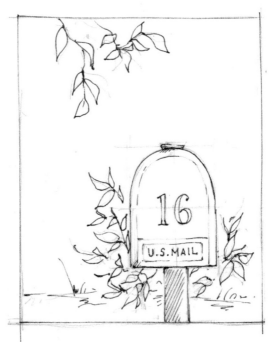

2 Begin to break down the parts of your subject by lightly drawing an outline shape in very light pencil. Make a bottom and top line, and, using a ruler or your pencil, make a rough measurement so that you can draw a center line vertically and horizontally through your subject.

3 Work on your drawing, using these guidelines the whole time, making sure that all elements are equally spaced on each side. Not all parts may be symmetrical. On the mailbox I selected it says "U.S. MAIL"—I have used my guides to help me decide where the letters fall.

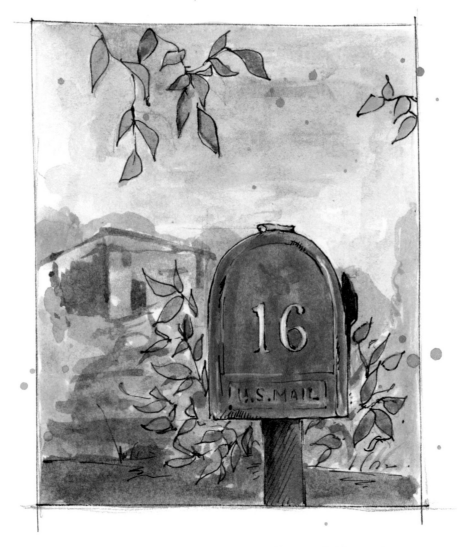

4 Once you have explored the symmetrical parts, left-to-right and top-to-bottom, think about the colors you intend to use and build the rest of your space considering these colors or elements. I chose to paint a blue mailbox, and the blues continue in the sky behind it. Maybe you have selected an apple or a flower: consider the color of these subjects as you plan the rest of your piece.

5 How you finish your drawing or painting is up to you, but it is nice to call attention to certain elements so your eye knows where to look and rest. I used atmospheric perspective and added a bit more detail to the leaves surrounding the mailbox in order to bring more attention to that area, as subjects closer to the viewer are more in focus.

PERSPECTIVE

How we translate a three-dimensional space or object to a two-dimensional surface is a large topic, and a very important one, that we must understand the basics of in order to draw things accurately. I am going to give you an overview of basic one-point and two-point perspective, and if you want to study further, then you can look into the many YouTube videos or more in-depth books on perspective drawing.

Everything we encounter in our world takes up a certain amount of three-dimensional space—from a small book on the table to the tallest building in New York City. How can we accurately convey that these things get smaller the farther away they are from us? When perspective is off, even in the smallest degree, the eye sees the mistake so clearly that our work can feel like a complete failure even though just one angle can be altered to remedy the mistake. It is only by learning the rules of perspective that we can recognize what is wrong. Once we know the rules, they become second nature.

I often do not use a ruler when I draw because I prefer to have a degree of playfulness to my lines. I think this adds a certain character. However, the imperfect lines are still at the correct angles, so my drawings of buildings, for example, appear (for the most part) accurate. Though if you are interested in executing complex architectural drawings, it is very comforting to plan your space and to use a ruler to ensure you are on the right track. So if you choose to tackle a very detailed perspective drawing or rendering, I do suggest using a ruler.

ONE-POINT PERSPECTIVE

We use one-point perspective when looking at a subject head-on as opposed to at an angle. There is always a horizon line in the distance, and one point, also known as the vanishing point, that falls on that line. You can find the horizon line by drawing very light lines going from each side of the subject back into space until they meet. If you look at my loose drawing of a bedroom (opposite), you can see that all the lines lead to one vanishing point in the center of the facing wall. I did not use a ruler when making my drawing, but by lightly sketching pencil lines to the vanishing point, I know where to draw my ink lines, and afterward can easily erase the looser pencil marks. Feel free to copy my drawing of the bedroom scene. Copying is a great way to learn!

Perspective also comes into play when drawing leaves, plants, animals, and humans; it is not just a technique reserved for architecture and man-made subjects. Everything we see close-up is larger the closer it is to our eyes and smaller as it recedes away from us, as shown in the sketch of the bunny below. We can exaggerate this technique (known as foreshortening) in order to make an image or subject pop off the page. It is often used at a dramatic angle for a dynamic effect. The same rules of perspective apply, as you can see by the light pencil lines in the sketch.

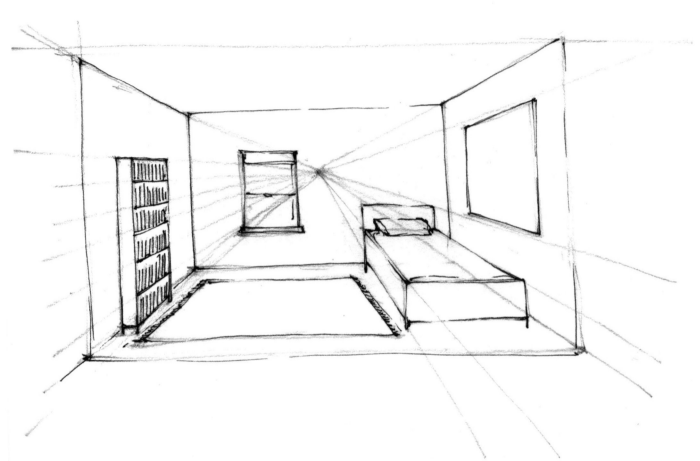

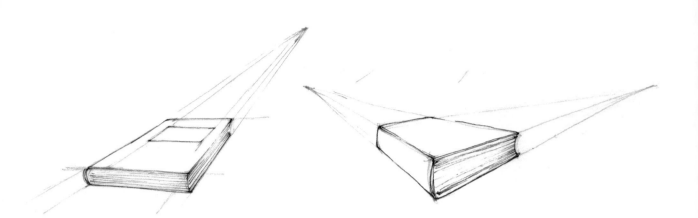

TWO-POINT PERSPECTIVE

If you want to render a subject from an angle where two sides are showing, you will need to find and softly indicate two vanishing points on your horizon line. This way, a single object or building can be accurately drawn by lightly sketching a series of lines from two sides. In all four examples above and opposite, you will see that I have loosely drawn lines on either side that join at a vanishing point on either end. I draw these light guidelines before or almost in unison with sketching the subject. The simplest way to determine where these points fall is to begin with the corner of your subject that is closest to you, and draw a straight line vertically. After you have a light horizontal and vertical line sketched, you will find one angle to help determine where the vanishing point will fall on the horizon line. You can use the thumb trick with your pencil (see page 58) to help find the best angle and side to begin with. I squint my eyes so I can more easily focus, hold my pencil out, align it with the top- or bottom-most angle, and then quite literally keep the pencil at the same angle and transfer it to my paper. I usually hold my paper or sketchbook up as I figure this out, so that I can keep the pencil at the same angle.

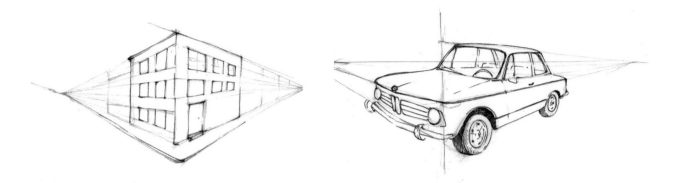

I would recommend getting a bunch of paper, a pencil, and a big eraser and beginning to sketch a few subjects, large and small, in one- and two-point perspective. The best and only way to really understand how it all works is to begin to play around with lines. Proper perspective is a challenge, and can take a long time to fully understand. The more you look at objects and buildings in space, the more you will see, and therefore your drawings will be more accurate. As you can see by my examples, I am far from one hundred percent accurate, as I do not use a ruler and some lines are a bit sketchy or loose. I even leave some lines out when I ink my drawings. This is an intentional and a stylistic choice. However, you might feel that a more precise perspective drawing approach is to your liking.

Two-Point Perspective

The best way to understand perspective is to experiment, look, and begin with a simple subject. I suggest starting with a box or a book and eventually graduating to a building with windows and doors. Follow these steps, and the details will fall into place.

Place your box or book in front of you, on an angle. It's there for reference; your initial drawing may not look exactly like it.

1 With a pencil, lightly draw a line left to right.

2 Next, make two marks on either end—these are the vanishing points.

3 Draw a vertical line not too close to your horizon line, one to two inches long. If your box or book is thinner, your corner line can be shorter. Just make sure it's not too close to the horizon line. For this exercise, the angles will get tricky the closer the corner line is to your horizon.

4 Draw lines from the top and
 bottom of your vertical line to the
 vanishing points on either side.

5 Next, draw the sides of your box or
 book. These lines will be parallel
 with your first vertical line.

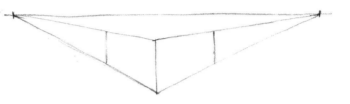

6 To complete the overall shape of
 your box or book, from the top of
 each side connect the lines to the
 opposite-corner vanishing points.

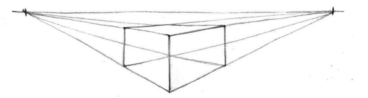

7 Outline the shape of your subject
 in a darker line or pen. Voilà!

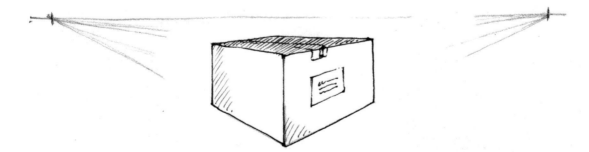

PROPORTIONS

Evaluating proportions as you begin your sketch is a significant first step. No matter the subject—an animal, a tool, a building, or a landscape—it is important to notice relative proportions as you begin to tackle your drawing. Every section or piece (an ear, a tree, the cap of a pen) can be looked at and evaluated in comparison to something else in order to arrive at proper sizing. A useful technique to measure proportions simply requires your pencil or pen and a squint of the eye to measure distances and shapes in comparison to others and to your overall space. In order to do this, you must hold your arm out from your body—the simplest way to know you are consistent is to hold your arm out completely until it is straight, with no bend in the elbow (if you hold it closer or farther away each time, your measurements will be off). Squint one eye so that your focus is clear, place the tip of the pencil on one edge of what you are measuring and then move your thumb down the barrel of your pencil or pen to the bottom of whatever it is you are measuring. Then do the same for areas nearby or attached to that area so you can see how far your thumb moves up and down. This is a visual measurement. It is not an exact science, but if you get the hang of it, it is a very useful strategy, and one you can practice regularly to compare sizes or distances in space. It takes a little getting used to, but if you experiment even just a few times, you will find that no other measuring tools are necessary to arriving at proper proportions. You can also use this technique to assess and compare angles.

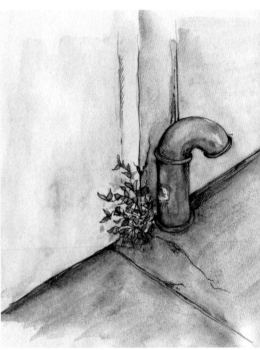

In this drawing, notice that the leaves rise up to the same height as the top horizontal joint on the pipe. Also notice that the width of the top portion of the pipe and the height of the bottom portion of the pipe are almost the same. As you observe and draw, these are the kinds of things to look out for.

As you experiment and study proportions, symmetry, balance, and perspective (especially perspective), I guarantee there will be a learning curve that may challenge you and cause you to feel incredibly humbled. It is a process. It is not easy. But I urge you to keep trying, as the more you look, the more you will see, and the more all that I have attempted to explain and work through with you will become clearer. It is my hope that you will gain enough of an understanding that you can use elements to deepen and enhance your own creative process. From the most precise to the intentionally jumbled perspective, knowing the basics, and being able to decipher what is happening as you observe your surroundings, will only help you on your path.

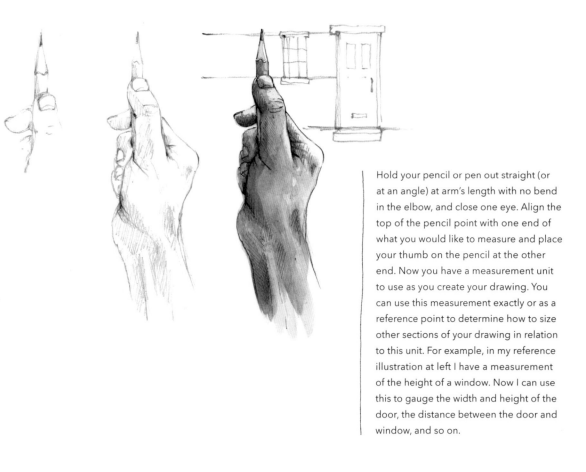

Hold your pencil or pen out straight (or at an angle) at arm's length with no bend in the elbow, and close one eye. Align the top of the pencil point with one end of what you would like to measure and place your thumb on the pencil at the other end. Now you have a measurement unit to use as you create your drawing. You can use this measurement exactly or as a reference point to determine how to size other sections of your drawing in relation to this unit. For example, in my reference illustration at left I have a measurement of the height of a window. Now I can use this to gauge the width and height of the door, the distance between the door and window, and so on.

A Chair

To put proportion into practice, let's try to draw a chair together. Choose one in your home, office, or at a quiet café. As there are so many chair designs out there, I will walk you through one, and hopefully the details that I discuss and break down as I draw my chair will resonate so that you get ideas on what to look for as you draw yours.

At first glance, a chair seems to be a pretty straightforward subject. But there are curves in the top seat, there are black wires that cross to reinforce the legs, there's a slight curve along each wooden leg, there are black screws in the legs, and so on. You can see that this chair is actually very complicated, and a challenge to draw.

1 First, just look. Spend a few moments just observing the chair and all of its parts. Examine the proportions of each part of the chair relative to the others. Again, we will use my chair, shown at right, as the example: How much space does the white seat take up within the box in comparison to the legs? Is the box divided in half? How far do the legs splay out from under the seat? Do they go past the outside of the molded seat? Is the lower screw where the supporting black crossbars connect in the center of each leg? Depending on the angle that the chair is drawn, you will see that a certain amount of perspective is involved. The angle I have chosen shows all four legs, but where do the back legs fall, and how much smaller and thinner have they become as they extend into the distance?

2 Using the measuring trick described on page 58, examine and ponder the proportions you see. Begin to place light lines—as light as possible so that they are easy to erase later on—as guidelines. Draw as many of these as you need.

3 Using your guidelines, begin to make your drawing in pencil. Your first sketch should be very light and rough as you figure out where the lines are meant to be.

4 Outline the lines you are confident about in pen. Feel free to use a ruler for the straight lines if that feels right for you.

5 Color in as desired, adding shadows underneath.

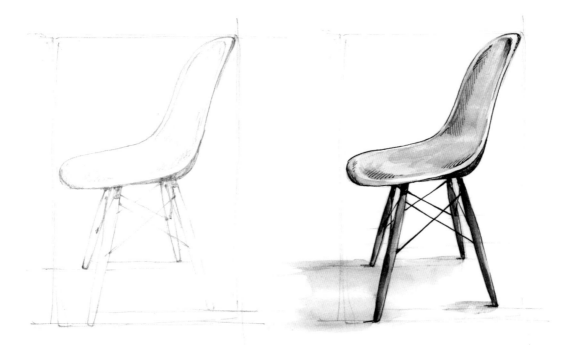

The top of the seat and the legs are almost exactly the same height. I know this by measuring with my pencil. The bottom ends of the black supporting crossbars attach to the legs right in the center of each leg. The front leg closest to me falls at the lowest point in my drawing.

7
29
2020

DRAWING FROM LIFE, REFERENCE, AND MEMORY

A question I am often answering about my work is whether I draw from life, a reference photo, or from memory. The answer is all three. I use whatever means necessary to arrive at a drawing I am happy with. If I am working on simple spot illustrations of, say, art supplies or food items, I very often render these from memory. The best advice I can give you about how this happens is to keep drawing from life and reference as often as possible. There is no hierarchy, in my opinion, about which of these three approaches is best, but rather it's a matter of finding the path that works in order to achieve your best work. The more you draw, the more it becomes a muscle-memory skill. If you were to draw your breakfast every day for a year, I am sure by the end of that stretch, many of the foods you eat would be easy to render from memory. I have been creating little spot drawings of simple items for so long, I now find it is easy to create a sandwich, for example, from memory, and therefore give it my own spin and style. I went to an event hosted by a few *New Yorker* cartoonists, and I was so impressed by how they illustrated a story created by the audience, right on the spot, with no reference. If you were to ask me to illustrate a person slipping on ice, for example, I would have to look up visuals online or ask one of my kids to fake a fall for reference. But I am sure that if I made it my goal to illustrate people in all sorts of positions and situations, practicing day after day, I would be less intimidated. Some skills come easier to certain artists, sure, but these cartoonists draw day after day after day, and have been doing so for years.

DRAWING FROM LIFE

Drawing from life simply comes down to having dedicated time and practice. If I take a walk on a nice day with the full intention of stopping to draw a scene outside or while sitting at a café, then I can carefully choose what to draw and have my supplies at hand. Drawing from life helps us see our subjects more clearly in space and in the world, and helps us understand scale. It uniquely challenges us to figure things out on the spot. The light shifts, people move, a parked car pulls away—things change and we have to adapt and deal with that in order to capture the essence of the moment on the page. Drawing from life outdoors, also known as en plein air (see page 111), is one of the most enjoyable processes. Feeling the fresh air, seeing the natural light move across a building or landscape, and rendering it on a surface, to me, is like stepping back in time to when life was slower, calmer, and technology free. You have paper and pencil and paint, and time to reflect and really study the world around you, deciding what to draw and how you would like to capture a moment of time.

Let's say you are sitting on a park bench. The street scene to your side may be busy, but the tree in that direction is lovely, and the leaves are changing color. You can draw some of the branches of the tree, and perhaps a touch of the sidewalk, so that you do not have to draw all of the perspective in the horizon with all of the moving parts. Just draw a hint of the road going back into space, and then you can illustrate some tree branches in greater detail. You can decide to focus on a whole scene or a small aspect. Just be sure that what you have chosen to focus on forces you to see the details, to really take in what's in front of you so that you feel you are practicing the skill of drawing from life.

Another wonderful way to practice drawing from life is to visit an art museum. Have you noticed that when you visit museums, there are often students or artists sitting by a piece of art with their sketchbook open? Sketching sculptures or frames or even parts of a painting

while at a museum or in a sculpture garden is an excellent way to draw from life, simply because it is quiet and nothing moves. You can sit for an hour or more without the worry of weather, wind, or changes of light. I will often visit the Met in New York City and spend hours drawing busts and figures or small parts of figures. Since many of the sculptures are stone, you can really see the forms and shadows clearly. Once you are comfortable with some of your techniques, I highly recommend doing this.

Drawing from Life

Look around your home and find a subject; something you used recently or something that relates to your life. Try to find a subject that would be difficult to render from memory—maybe a stack of magazines or a treasured bracelet. Next, for reference, take a photo before you begin in case the subject moves or the light changes. Study your subject—its proportions, shapes, and colors—for a while. Then draw it lightly in pencil, capturing as much detail as you can. Now turn away from the subject to complete your drawing. It's okay to glance back to check on shadows or color, but try not to. It's also okay if some elements are not completely accurate. Looking minimally will give the drawing more of your personal style. The drawing is your interpretation of this subject in your world.

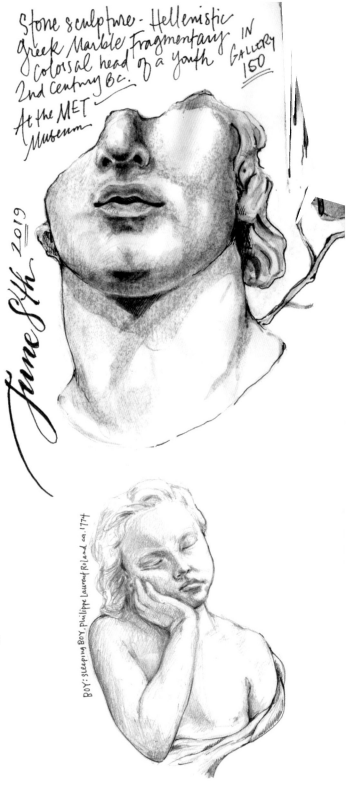

Stone sculpture - Hellenistic greek Marble Fragmentary colossal head of a youth IN GALLERY 2nd Century B.C. 150 At the MET Museum

June 8th 2019

BOY: sleeping BOY, Philippe Laurent Roland ca. 1774

DRAWING FROM REFERENCE

Drawing from reference—such as from a photograph—is useful for a moment of action, such as a fly buzzing in your ear, the wildly excited puppy that won't sit still, or a child running through the park, and can provide the time and focus to hone certain details and techniques, as our subject remains static for us to study. Taking a photo may also be useful when you don't have the time to draw or your supplies handy. It is important as you work from reference to be sure that you are making the artwork with your own flair and personality. Copying is an important part of learning to draw—we are often instructed in art class to copy masterworks—but after the understanding of form, perspective, shadow, and light are established, it's time to use reference only as a means

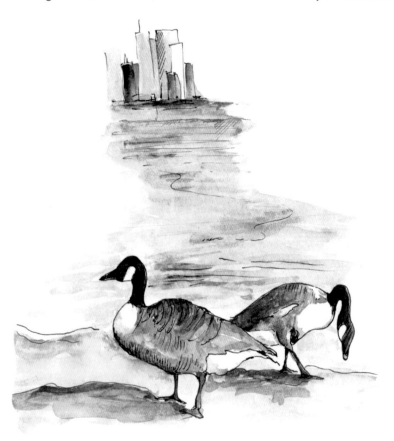

I loosely sketched this scene from life, but then took a photograph as the ducks were moving around in the water. The final rendering is a result of both working from life and from photo reference.

to make your artwork as accurate (or as inaccurate!) as your personal style requires. I use reference because I like to draw things as they are. But I am careful to work from a few images at once, so I'm not just replicating one thing, and after the sketching phase, I turn away from the reference and create the rest from memory.

When I would like to draw a dog waiting by a coffee shop or my son playing soccer, for example, I always snap a photograph with my phone. I know that if I were to draw these scenes from memory, it would wind up looking like a caricature, and I usually prefer to draw things as I see them, as they are in real life. It is a style choice, and I find it gratifying to copy a photograph so that the scene is captured on paper in a fashion that is as close to real life as possible. I love taking photographs, too, and enjoy looking back later in the day to determine if a photograph should be left as a photograph or if I think it would be better captured in paint.

Another example of a time when reference is necessary is when you haven't had the time to pull out your camera and only have a memory you would like to capture on paper. Let's say your glass of wine spills at dinner while you are with friends. You don't take a photograph in that moment because that would be a bit awkward, but later on you feel compelled to illustrate a spilled glass of wine. Google "spilled glass of wine," and use multiple images to create your own scene. I do this often, and as long as I do not copy another illustration or image exactly, the process works well for my needs. I had to illustrate fly-fishing flies for a job, and with no access to handmade flies, I had to search online for reference. I was told the specific type to look for, and created my illustrations based on many images I found. The result is an accurate representation, but my illustrations have a character that is unique to my style. They were not traced or copied exactly, but someone in the fly-fishing world would be able to recognize them. Most illustrators use reference to create their drawings. I prefer to use my own reference images if at all possible, but there are times when it is not.

Drawing from Life, Reference, and Memory

To combine drawing from life, reference, and memory, find something that you are pretty familiar with as you go about your day: a mailbox on the corner, your own pet whose face you know so well, a bowl of soup, or your morning coffee mug. Make sure to select something that you can sit with for as long as you need to, to draw it from life (so if you decide on your pet, then it's a good idea to draw him/her when they're sleeping). Take a photograph of your subject before you begin. Once you have selected what you would like to draw, I challenge you to draw it first from life, second from reference, and last from memory. I prefer to draw from memory last in this exercise because after studying the subject as you draw from life and from your reference photograph, you will familiarize yourself with it that much better. Practicing drawing the same subject by these three approaches goes back to our discussion of really, truly *seeing* a subject as you draw it. Be sure not to create your drawings directly next to one another but on three separate surfaces or pages of a sketchbook. It is interesting to see what happens! Which one is your favorite?

Glyka, whom we occasionally dog-sit, in three ways: from memory, from life, and from a photograph. To my surprise, I like the drawing I made of her from memory best. I can tell her form and features are a bit more animated than in real life, but I was able to capture her sweetness in a way I was surprised by.

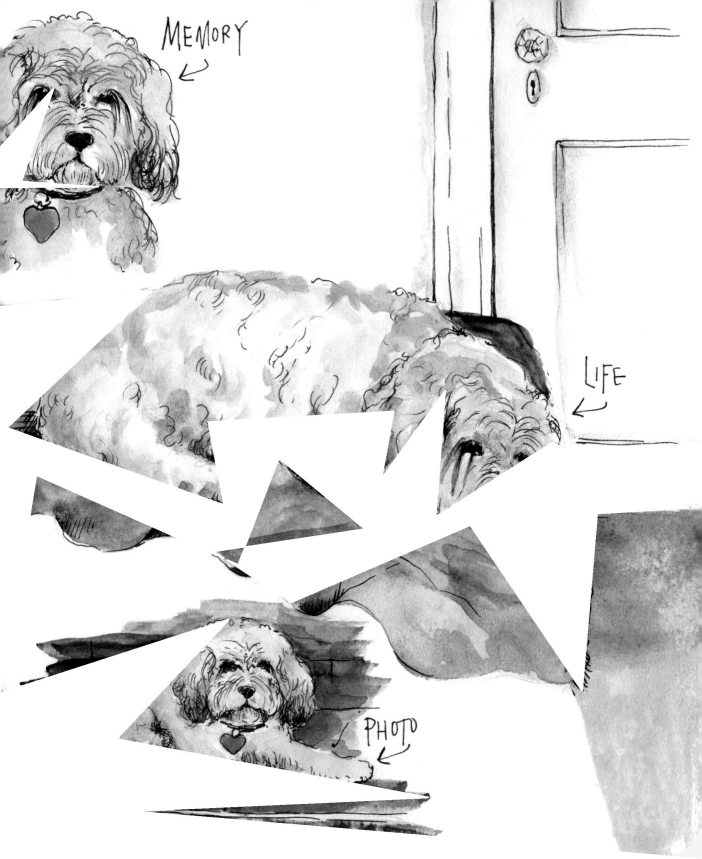

Typography and Lettering and the Role They Play in Your Artwork

Experimenting with typography, calligraphy, and your natural handwriting can be an asset—or a simple addition to consider using—as you express moments of your life through your artwork. Whether you are working on an urban sketch journal entry of a restaurant with an awesome vintage sign, or you have developed an interesting signature stamp using your monogram, or you like to incorporate words into your abstract paintings, adding words to your work can inject extra inspiration. Words can also add clarity to a piece of your work that can help you to remember a moment in time. Though not essential, knowing some simple rules of typography can always be helpful.

Basic Typography Anatomy

CAP HEIGHT

SERIF, THE LITTLE FEET OR FINISHING STROKES AT THE ENDS OF THE LETTERFORMS

ASCENDER, EXTENDS ABOVE X-HEIGHT

Sixty

X-HEIGHT, BASED ON HEIGHT OF A LOWERCASE X

SERIF

DESCENDER, FALLS BELOW X-HEIGHT

LIGATURE, TWO LETTERS THAT CONNECT, LIKE ffi or fl

Sixty ← THIS IS AN EXAMPLE OF SANS SERIF, WHERE LETTERS HAVE NO EXTRA STROKES

LEADING, SPACE BETWEEN LINES KERNING, SPACE BETWEEN LETTERS

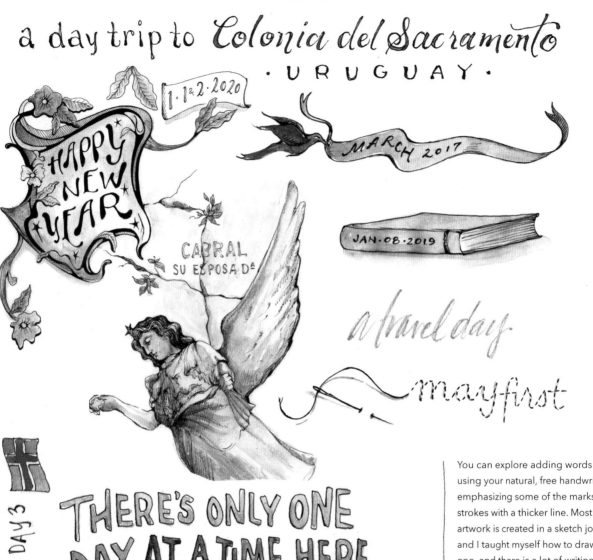

a day trip to *Colonia del Sacramento*
· U R U G U A Y ·

1 · 1 & 2 · 2020

MARCH 2017

HAPPY NEW YEAR

CABRAL
SU ESPOSA Dª

JAN·08·2019

a travel day

mayfirst

AUG 12 — DAY 3

THERE'S ONLY ONE DAY AT A TIME HERE, THEN IT'S TONIGHT AND THEN TOMORROW WILL BE TODAY AGAIN ~

BOB DYLAN

You can explore adding words using your natural, free handwriting, emphasizing some of the marks or strokes with a thicker line. Most of my artwork is created in a sketch journal and I taught myself how to draw in one, and there is a lot of writing and words involved in the work I create. I also studied typography in college and spent the first part of my career working as a graphic designer, so drawing letters comes naturally and provides me with great freedom as I translate the world around me onto paper. I love the letterform and believe there is no right or wrong way to make the letters of the alphabet. These are some examples of how I use typography and lettering in my work.

RAKING LEAVES and FALLEN BRANCHES
AFTER ISAIAS BLOWS THEM around.

FROM SKETCH TO COLOR

I begin any creative project, whether note taking, planning a composition, or sketching a figure, with a sharp pencil and a big eraser. It's very important to understand what the pencil can do, and to make sure that you have a light touch to your sketches, building pressure as you become more confident about the lines. We discussed pencil marks in the beginning drawing exercises (pages 28-31), and here you will be able to put that practice into action as we begin working from sketch to color. When my sketches are about eighty percent finished, I like to outline them in ink. That way, my ink drawings can follow a basic outline but also create their own fluidity and character. I often leave some of the pencil marks visible as a reminder of the layers and the process needed to arrive at my finished illustration. But please note that ink is not a necessary step. It is something I choose to do but is not at all what needs to be included in order to arrive at a finished drawing. If you prefer to skip outlining in ink and just begin to paint or color right on top of your pencil sketch, feel free to do so.

INK

As you begin to experiment with different permanent fine-line pens, nibs (the point that comes in contact with the paper), and thicknesses of nibs, you will quickly discover what works nicely in your hand and with your natural pressure. I believe that a favorite pen is one of the most personal choices as far as selecting art supplies. I found my favorite pen to draw with about five years ago and have been loyal to it ever since. It's a Copic Multiliner SP with a size 0.1 nib. I spoke at length about this pen in *Draw Your Day* and continue to sing its praises. It is not the easiest pen to deal with, as you have to replace the nibs and ink cartridges. But it is not as high maintenance as a fountain pen or the technical Rapidograph pens my mother used when I was growing up. It is a bit too expensive to replace entirely when the ink is low or the nib wears down, so I prefer to purchase the refills and carry them around in my tool pouch. There is a quality to the ink and the way it sits right on top of the surface without bleeding into the paper fibers that I find so lovely. The Copic ink does not take too long to dry before you can erase the pencil underneath, and the ink is fully waterproof. I can apply layers of paint as watery washes on top without any running or bleeding. The most important thing is to make sure that you select the nib that creates the thinnest line you are comfortable making so that those lines can be built on to add weight. You don't want your initial marks to be too thick. The thickness can be built upon a single line, or you can add dimension and weight using a few pen-and-ink techniques.

If you are interested in drawing with your pens beyond an outline, the two most common ink techniques are stippling and crosshatching. Stippling is a way of using your pen to shade and build dimension by creating a series of small dots. The more dots you make, the darker the area becomes. Crosshatching allows you to shade, and builds dimension by creating a series of parallel lines at different overlapping angles. I personally prefer crosshatching to add dimension to my drawings, as

EXTRA-FINE POINT

A TOUCH THICKER — MY HAPPY PLACE!
(COPIC MULTILINER O.1 NIB)

PIGMA MICRON PN (PLASTIC NIB)
MY GO-TO FOR SLIGHTLY THICKER LINES

ink

COMBINING TWO PENS, ADDING WEIGHT FOR SHADOWS
OR INTERESTING LINES AND MARKS AND WORDS

I ALWAYS HAVE ONE THICK PEN OR BRUSH PEN FOR
LARGE AREAS OF BLACK, OR FOR THICKER LETTERING.
I DON'T USE IT OFTEN, BUT IT'S NICE TO HAVE ON HAND.

 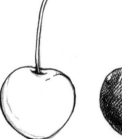 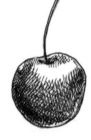 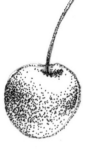 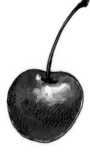

PENCIL
SKETCH

FIRST INK:
OUTLINE, ADDING
WEIGHT FOR A
SUGGESTION OF
DIMENSION AND
SHADOW.

CROSSHATCHING:
A SERIES OF
OVERLAPPING
LINES.

STIPPLING:
A SERIES OF
DOTS.

MY WINNING
COMBINATION
OF INK AND PAINT.

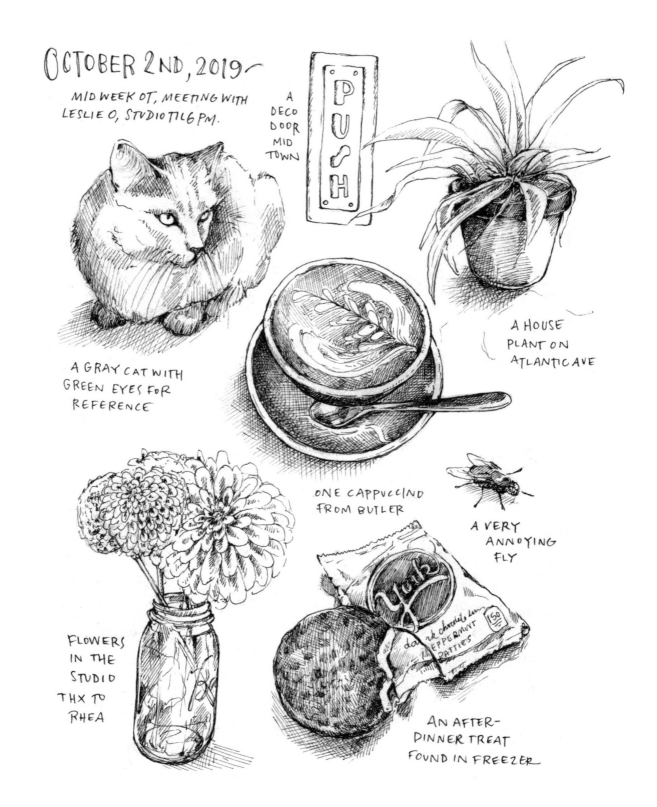

OCTOBER 2ND, 2019

MID WEEK OT, MEETING WITH
LESLIE O, STUDIO TIL 6 PM.

A DECO DOOR MID TOWN

PUSH

A GRAY CAT WITH
GREEN EYES FOR
REFERENCE

A HOUSE
PLANT ON
ATLANTIC AVE

ONE CAPPUCCINO
FROM BUTLER

A VERY
ANNOYING
FLY

FLOWERS
IN THE
STUDIO
THX TO
RHEA

AN AFTER-
DINNER TREAT
FOUND IN FREEZER

I like the look of this style, and the process is less time-consuming than stippling. I invite you to try both to see what you like best.

Yes, stippling can take time, but the effect is so beautiful. I don't have the patience and have always preferred to use a crosshatch technique to create my drawings. But I do often combine the two, or occasionally, if I am drawing something where just a touch of shading is needed, little dots do the trick better than lines. I highly recommend practicing the techniques in five to six boxes (as below) to see what you think. For me it took about five times as long to fill the boxes with varying amounts of small dots than it did to create the boxes using the crosshatch technique.

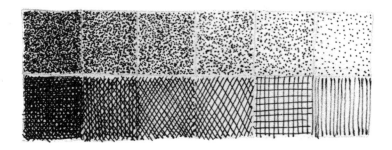

You can experiment with ink in so many other ways, too. There are dip pens that you can use to draw and write with that create beautiful marks. Often little leaks or splashes or drips can add a spontaneous quality to your work. You can paint with inks, and even use straws or pieces of wood to experiment with making marks in ink on your work. We think of ink in one way, arriving on our page through a plastic or metal tool that we call a pen, but try and think of ink as another medium to experiment and play with.

Exercises in Ink

Draw three rows of six boxes and follow the steps to create darkness
with the tip of your pen.

Begin on the left and fill the boxes with as many small dots and crossed
lines as it takes to make it almost entirely black. Then proceed to fill
each following square with just a little bit fewer dots and lines until you
reach the end. Or you can work in reverse, starting with fewer dots and
lines and gradually making the squares darker and darker until you
reach the last.

STIPPLING

CROSS-HATCHING

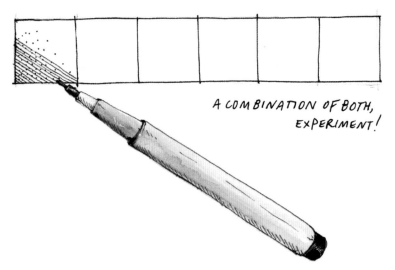

A COMBINATION OF BOTH,
EXPERIMENT!

DRAWING WITH COLOR

After I have my initial drawing down in ink, I almost always use water-color and gouache to color my artwork. I occasionally use a handful of other materials, like water-soluble pastels, various inks, and colored pencils. I suggest you experiment with combining paint and solid pigments, discovering what happens when you paint a light wash of watercolor, followed by a layer of water-soluble colored pencils and pastels, adding gouache at the end for highlights and rich opaque color.

Teaching how to paint with watercolors feels a touch out of my comfort zone. This may be surprising, but it is due to the fact that I taught myself the medium on paper that was not meant for paint and I used a plastic water brush. The paper would pill sometimes, and some areas would not take the paint at all. I would remedy the issues by using gouache or by collaging on top of the errors. At the time, it was more important for me to stick with the sketchbook I had grown so attached to. I figured it was my space to experiment, and I liked the paper for other reasons. It wasn't until about four years into my art-making and drawing practice that I felt worthy of proper materials. I did some freelance work on proper watercolor papers, and realized what I was missing out on. Once my eyes opened to the world of handmade paints and beautiful brushes, it was hard to stop myself from purchasing everything in sight!

But you see, calling myself an authority and expert on the subject feels a little uncomfortable because I did not study watercolor painting in school, nor have I taken tutorials or workshops on the subject. I learned through a ton of trial and error, and many of the mistakes I have made happened at the painting stage. Day after day I have played around with my paints, discovering what colors have more granular qualities (meaning more of a sandlike texture), which are most opaque, which colors work best for shadows and for skin tones. I have spent hours experimenting with washes and varying amounts of water. I like to

paint a little messier than other watercolor artists. I enjoy when the paint goes outside of the lines, and little splashes and drips happen spontaneously. These qualities have become a part of my work. What I particularly enjoy about freeform, loose paint is that it is a contrast to the style of drawing I have developed. I draw things as I see them, with proper proportions, perspective, and symmetry, and therefore the freer paint style gives my work a casual and less precious feeling.

Though I am not an expert, I have learned a lot through trial and error and my own practice. I have various paints from synthetic to the most natural made from minerals and pigments from the earth. I prefer my natural paints, as it gives me peace of mind knowing that most are nontoxic and have been created with care and love by people who have put in the time and research to make them. (I have listed a few of my favorite lines of handmade paints in the Resources on page 162.) When you purchase your paints, you might find that some colors or brands will produce a solid, smooth wash, whereas others have more of a life of their own, and the washes vary, or have texture. The texture is also known as granulation, and when I come across colors that are more granular, almost as if little pieces of fine sand are mixed in, I embrace it and really enjoy seeing what happens. However, I can understand that other artists might find the texture annoying and feel it takes away from the precise quality they are looking for. Typically, less expensive or beginner sets of watercolor will not have these granular qualities, but it is important to be aware of what you might find if you decide to invest in handmade paints or more expensive artist-grade paints. Best is to do some research and play around with one or two colors first to see if you like what happens.

The interesting thing about watercolor is that it is so often one of the first set of art-making materials we will think of or purchase for kids; it is easily available and is transportable. I have even seen watercolors in tiny, cheap toys. But don't let their availability fool you: Painting with watercolor is not easy. It takes time and patience to learn. It is all about

A light, watery wash (left) and a more opaque color using less water (right).

how much water does what, and which paints will appear more vibrant or opaque than others depending on the amount of water that is mixed in. If you want to fill a large area with light color, you will need to use a separate palette—a plate will work just fine; don't worry, the paints will wash right off—so that you can mix more paint. Adding more water at first is a good idea, so that you don't put down too much pigment from the start. Building layers is key to painting with watercolor. Sometimes you can blot with a rag and lift the paint off if you have put down too much, but some colors will seep into the paper right away and then there is no turning back. Waiting for the paint to dry if you would like to add fine details on top of your larger areas of color is very important, too. If you don't wait, and there is still a lot of wetness to the paper, the finer details will bleed or blend into the background. You can also use the bleeding and flowing paint as an intentional part of your work. But planning and knowing what will happen can only be achieved through practice. And even when you think you have a plan, know that watercolors often have a life of their own, so be aware that unexpected bleeding of color, or areas where the paint dries with a different look than it appeared as you were working, are a part of the beauty of the medium.

Gouache I find more predictable. That is why I typically use it on top of (or sometimes in conjunction with) my watercolors. I really don't know if this is a regular practice. Some purists may think my suggestion of using both is taboo, but I do what works for me without the strain of any rules. I was told that a proper watercolor painting will leave the white of the paper showing through where a highlight should appear. But sometimes the paint will flow too much, or the light will change, and I decide that adding pops of white will enhance my work. I use white gouache at these times because I can layer it on top. A good example is a cat's white whiskers. I will paint little highlights or fine hairs shining in the light or white whiskers using a thick white gouache (meaning I have not mixed too much water with it) with a fine brush. Or I will add

thicker gouache colors where I want things to pop. A vintage blue car, for example, parked on the street: The street and background will be painted with light washes of watercolor and then I go in with more details and opaque color to create the shiny blue car.

I can't recommend enough, if you are new to watercolor or gouache, that you take the time to experiment. The only way to know what process works for you—how much water does what, what brush works best for the work you are creating, what mixing two colors together will do, how the paints flow on the paper, whether it be hot press or cold press—is by experimentation. Buy a few pieces of less expensive paper or watercolor block, and just play. I am an impatient artist and enjoy experimenting, revealing my mistakes and imperfections as I go. But I cannot count the amount of times that I have put too much pigment down or didn't wait for an area to dry, and have had to blot, panic, figure out how to fix what I have done. These moments by now are a part of my process and growth, but there are times when I have to start over (or collage over an area). Take the time to play and figure out all that you can do. Your hand and touch are unique to you, so what you create with your paints may surprise you. There is no right way, but know that these mediums are what they are and have their limitations. I am still learning with you!

To help you decide how you would like to add color to your work and to guide you through your own experimentation, here are some examples of my process for adding color. I usually outline in ink, but sometimes decide that that look is a little heavy, so I also play with paint or use colored pencil only.

a little red bird lands on the tree next to us — and flies away quickly

a little red bird lands on the tree next to us — and flies away quickly

a little red bird lands on the tree next to us — and flies away quickly

a little red bird lands on the tree next to us — and flies away quickly

a little red bird lands on the tree next to us — and flies away quickly

a little red bird lands on the tree next to us — and flies away quickly

a little red bird lands on the tree next to us — and flies away quickly

As you can see from the seven stages of drawing a little red bird, I began with a light pencil sketch. As I felt confident that my pencil lines were in the right place, I added weight to these lines using more pressure with my pencil. I then added ink to the outlines. After the ink was down, I lightly erased the pencil underneath. A light wash of color was added and then built on with more pigmented watercolor (mixing more paint with less water) and gouache. The highlights in the black wings were accentuated using white gouache, and a more delicate touch was applied to create the thinner lines. The finished stage shows the bird with a bit of blue sky in the background to place the tree branch in nature.

Playing with Color

I invite you to play a little bit with color for this next exercise. Think of this as an experiment, and don't worry too much about the outcome. The less you worry and obsess over perfection, the freer you will be to come to a coloring style that best suits your natural hand and instincts. The goal here is to simply try a few styles and mediums (or, if you only have one type of medium available to you—watercolor for example— you can try three styles using that medium alone).

1 Choose a subject—a piece of fruit is an excellent choice for this challenge—and place it on a white or light-colored surface. That way you can easily see the shadows underneath.

2 With a pencil, draw it loosely three times.

3 Add color to each drawing in three different ways, making sure that you add a layer of richer and darker pigment to the side that falls into shadow. As you experiment with darker and lighter colors, really look at where the shadows begin to fade into a darker color and where the highlights are, and use your colors to translate them onto your page.

4 Notice any reflective light (see "A Visual Breakdown of Light and Shadow" pages 40–41). Make sure you keep the highlights white as you build the color around them. Try coloring one of them very loosely and messily, another more tidily, try one painted with less water, one with more watery washes, one with markers, one with colored pencil, one with more ink and stippling or crosshatching, and the like. In fact, if you would like to color more than three, go right ahead. Circle the one that you like the best.

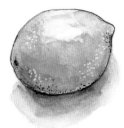

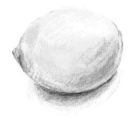

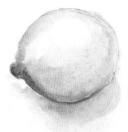

This lemon was outlined in ink, with a little bit of stippling (see page 77) around the bottom, then painted using watercolors and a small bit of gouache for the more intense color areas and to paint the highlights in white.

This lemon was colored using only water-soluble colored pencils and a small touch of water.

And this one was painted using only light washes of watercolor.

Challenging yourself with the exercise in this section, from sketch to color, can be integral to establishing your own unique style. If you decide to pick up a pencil that feels good in your hand and you draw for hours using this one-and-only tool, that is perfectly fine. Or if you decide to sketch, ink, paint in watercolor, and layer with gouache, as I often do, well, that is great, too. I believe that any artist, at any level of practice and skill, can benefit greatly from experimenting with mediums and techniques. There are countless formulas for creating finished artwork, and of course "finished" is up for interpretation as well. I recommend that you practice with a minimal amount of investment, especially if you are doubting that a medium is right for you. If you are not sure you will enjoy painting with gouache, then just purchase two or three colors. It is not a great feeling to buy an expensive set of coloring materials and then discover you don't enjoy working in that medium. Consider this a time to play and experiment, and once you discover what brings you the most creative joy, you can then build on the practice, and the materials, over time.

COMPOSITION

One of the questions I am asked by followers and students most often is, "How do you arrange your pages?" When I first started sharing my journal pages on Instagram, before I could draw very well and just arranged words and little doodles, I was asked this question. For this reason, I believe that teaching others about my arrangements of subject matter and compositions played a large role in getting me to where I am today in my career, and eventually to writing this very book. Even before my drawings were practiced and I was hired to make them, I had an innate sense of big and little, the Rule of Thirds (see page 88, idea 2), layering of subjects, leading lines, and focal point. If you have studied composition in the past, some of these terms may sound familiar. I took design and photography classes from the time I was in middle school, and certain messages have become second nature to me. When you look at art long enough, you just retain a sense of what catches the eye, and therefore I have a natural sense of where I want to place things and how big I want things to be in relation to other things. This sensibility stems from all of those years of designing, art-making, and observing. And, more important, it has come from regular practice. I choose not to paint one scene or thing but to arrange and paint many things at once. Over and over again, I have thought about how to bring life and focus to one area of a page while arranging other things to be discovered on closer inspection. As discussed in other sections of this book, we can learn much from the "rules," but so often these rules are broken—and beautiful and successful work is still created! There are three things that I find are important to successful compositions: do not be afraid of the edge of your page or surface, work in threes as often as possible, and layer your subjects on top of each other.

TWELVE SAMPLE IDEAS FOR COMPOSITION

On the following pages I have shared twelve ideas and samples for compositions; they are oriented vertically but can easily be turned to work horizontally or on a square surface. It is my goal for you to feel inspired by them but to know that they are just rough guides. What you choose to draw will determine the best composition choice for you. And it is very likely that none of these twelve options will work perfectly for what you would like to achieve. Use them as you please. They are here for you to photocopy, scan, blow up, use as templates, or simply be viewed as inspiration.

1 Whether you are creating work in a sketch journal or on another surface, feel free to ignore the areas of writing if they do not suit your needs. In this first example of a "hero image," the idea is that you have one main focus—the subject—in the center of your work. There can simply be air around this central image, or you can create small scenes, spot illustrations, or writings around it.

2 Divide your page into nine even sections (see the dotted lines) with a very light pencil. Wherever two of the lines meet or cross is an area of focus. This is a very popular and useful trick called the Rule of Thirds. Have you ever seen a photograph where the focal point is almost bleeding from the edge, and it feels a bit uncomfortable to the eye? This is a way to avoid that, and leave the eye focusing in a more comfortable place: not perfectly centered but also not too close to an edge.

3 Draw three items lightly in pencil, with parts touching or overlapping. Once you have the initial sketch down, you can then begin to erase marks so that one item will fall in front of the others. Make an effort to have these items fall right off the sides of the page on at least three of the four sides (see example on page 92).

4 Explore cascading illustrations or overlapping drawings. Start large at the bottom, and have the illustrations or drawings get smaller as they go back in space. Again, make an effort to lightly sketch various things right on top of one another. Once you have the initial sketch down, you can begin to erase marks so that one item will fall in front of the other.

5 Divide your surface into three uneven sections. These can be any shape you choose. Fill each part with a different color or pattern or

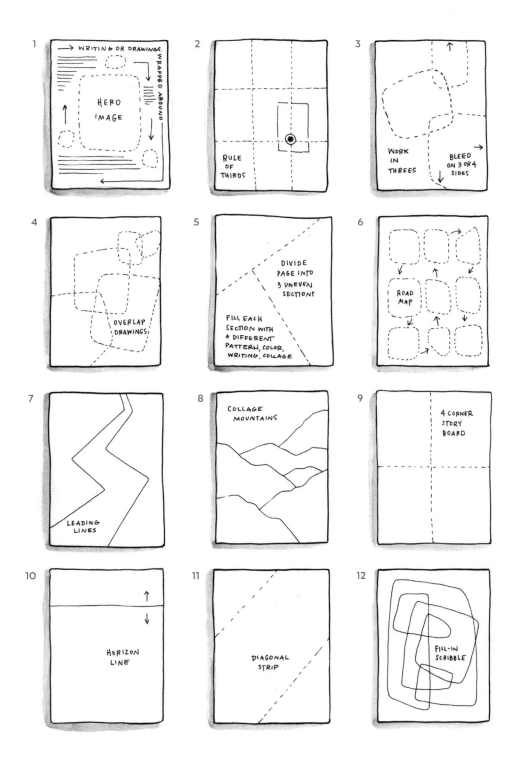

painting. Imagine a landscape in one, then fill the others with patterns or color that you find in the landscape you have painted.

6 Make a road map. I have a lot of fun with this variation of drawing my days on paper. Begin in the center and work your way around, or begin in the upper left corner, working your way down and back up again, drawing small items that tell a whole story. Maybe you have gone on a nature walk; draw some of the leaves and flowers that you encounter. These can all be the same size or you can play with scale, making some smaller or larger than the others.

7 Use leading lines. These are not to be followed exactly, but the idea is that a road or sort of dramatic line will lead the eye from the foreground to the background as it descends into space, whether you draw a staircase, a train track, or the lines in an abstract pattern. These lines take your eyes from one place to another in space.

8 Collage or pattern mountains. Glue or paint one pattern down and then layer patterns on top of one another until you get to the bottom. If you would like to use collage, this is a great exercise: tearing papers and layering them one on top of another. Or you could use this idea for areas of writing or painted color. It is here for inspiration. A mountain landscape can stimulate so many ideas, and is not intended to be taken literally!

9 Divide your page into four even sections lightly in pencil. Have fun telling a four-part story.

10 Play around with the idea of a horizon line. This can be interpreted however you choose. Literally, if you wish, in creating a landscape painting. Or have color or abstract patterns recede toward the horizon, with a blue sky above. The idea is that you are dividing your work surface into two parts, with the horizontal division falling somewhere off center.

11 Make diagonal strips. As with idea 3, divide your surface or page into three parts, using diagonal lines. Fill these areas with different colors, patterns, or illustrations.

12 This is a favorite of mine; I used to do this with my kids. Take a pencil—or even go for it in pen—and draw one line, without lifting it from the page, in an abstract and spontaneous scribble. You can have the ends meet up or have them fall right off the side of the page if you do not know how or where to end your line. Then have fun filling the areas with different colors, stripes, patterns, writings, or illustrations.

This is a step-by-step process of a piece I created using all four sides of the page. This composition doesn't follow any one of my examples exactly, but is a combination of a few. There are three main areas of focus: the cat, the butterfly, and the flower. I have also layered things on top of each other. The rain and nature scene falls right on top of the doorway that the cat is peeking through.

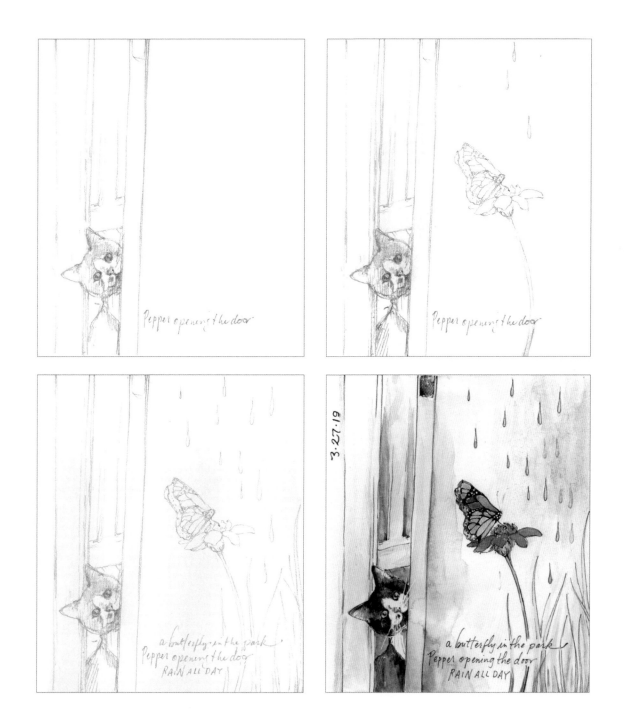

Here is another example of a step-by-step process showing how I draw things directly on top of each other and later make decisions on what objects or subjects fall in front of others simply by using my eraser. In the first sketch at right, I have the spoon with yogurt drawn right over the pillow. The paintbrush is drawn right over the bottle of kombucha. Once I decided what elements would be hidden behind others, I then drew everything in ink. In order to layer your subjects and play with scale (some things coming closer to you and others descending away), just sketch lightly. Make it messy. Use light pencil pressure so your lines are easily erasable.

Whether you decide to layer an arrangement of subjects at various sizes, to make a clean grid of equally spaced boxes, or to create one scene smack in the middle of your paper or work surface, remember that the rules of ideal composition can be taken or left behind. It is all good. What makes a painting or drawing inviting to the eye is not always true to a set of guidelines. And perhaps none of the ideas that I have shared in this section may work for what you wish to convey. Who's to say that one subject falling off the left edge of the page, with the rest of the page a solid color or even left blank, can't be your most successful piece of art? I certainly will never tell you that won't work. But I can say that a lot of work does fail to engage the senses and the eye.

Sometimes what works is hard to describe; it simply flows nicely. I highly recommend planning your page or surface with a very light sketch first. The pencil can help you develop a composition before committing and laying down something you wish you could move a couple of inches or make larger. Use the pencil, make a plan, then build on your work knowing that you have a clear path ahead of you. Like anything else, it takes practice, but the more you play with scale, color, and line, and engage with the edges of your page or surface, the more compositions you will discover successful.

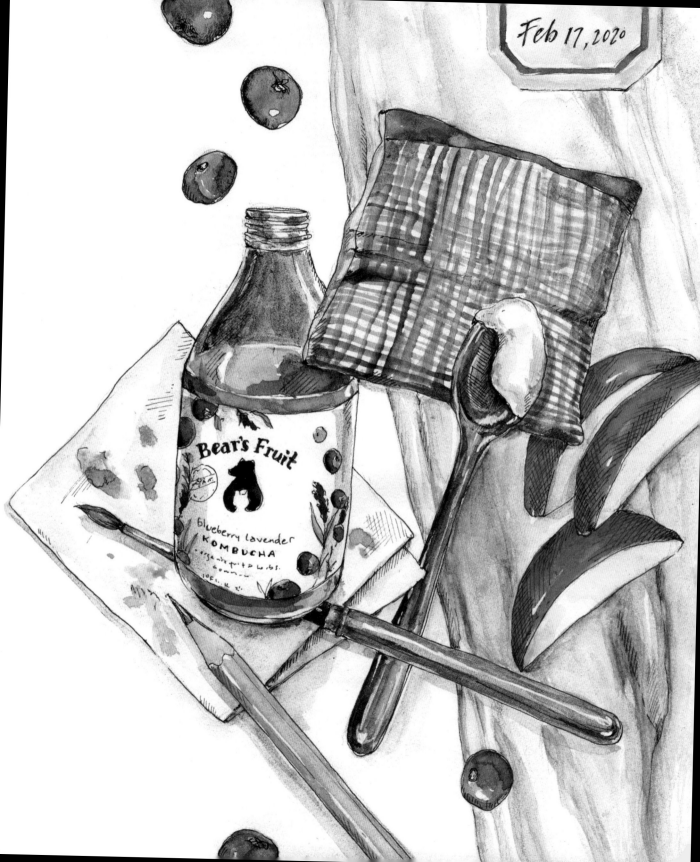

Feb 17, 2020

Bear's Fruit

blueberry lavender
KOMBUCHA

Edition

GET-THERE
(SYSTEM)

DIRECTORY
TTAN & BRONX

W YORK

May 11th, 2019 ~
I found an almost
100 year old
NYC street directory
AND
@ 7:30 AM I eat
GREEN APPLE

E ANSWER IS DREAMS.
EAMING ON AND ON.
TERING THE WORLD OF
EAMS AND NEVER COMING
T. LIVING IN DREAMS FOR
E REST OF TIME.
~Murakami

Feb 20th
2020

PART 2
Inspirational and
Motivational Lessons

I see this little girl on a
short rainy day walk – it's
Sunday and boys are home
watching football. Malcolm
is cooking a chili. I need some
air. She is walking with who I guess
is her grandparents. And I decide she
is pointing to the subway on Pineapple street,
holding a stick, getting a bit wet

"It's this way"

PRESERVING MOMENTS IN TIME

One of the benefits of an art-making practice, whether it's within a journal or sketchbook or on canvas, is the connection to our spiritual side. The practice deepens our understanding of our anxiety, stress, and sadness, or our joy, excitement, love, and appreciation. All of our emotions come through on the surface we are working on. I draw things and people the way I see them, and remember them as a way of keeping hold of time. When I look back, not only do I remember what I saw but how I felt as I saw it. The daily sketch journal is a wonderful way to capture important memories, but you may create a series of three small paintings, or a triptych, or paint one single canvas. My sister is a painter, and she created a series of semi-abstract works on canvas that recalled our family trip to Israel. And as I continue my practice year after year (I'm currently on my thirty-sixth sketch journal, and countless sketchbooks precede them!), I've come up with little ways and rituals to capture the memories and moments that matter most to me. Such a practice will look and feel different for everyone. It is not my place to tell you what to capture in your work that will take you back to a moment. For some people this may look like color and abstract marks; for others, like me, the work will be very literal. For example, when recalling a special moment at the top of a mountain in the Andes, I illustrated the scene just as I remembered it, with little reference to my photographs.

My entire art-making practice has evolved into a memory-tracking practice. Almost everything I put on paper directly relates to the things I do and see. I work hard to explore all of the ways that recalling a moment can look, but I make sure there is at least one element that will not only take me back to a scene (like a photograph will) but also capture the feelings felt in that particular moment in time. A word can do that, or the color or expression of line: dark, messy lines can evoke a stressful time, whereas precise and fluid lines can convey calmness.

Sometimes what you are feeling and what you feel inspired to capture are not directly related. For example, on one particularly stressful morning, my kids were slow getting ready for school, and I had to be somewhere all the way uptown. I got on the subway, and there was a woman sitting with her dog in a bag at her feet. The dog was so calm and content in its carrying bag that I immediately felt calmer myself. Instead of drawing a bunch of stressful lines and marks, I drew the dog, which made me feel better. I asked the woman if I could snap a photo and if she would share the dog's name with me. I love this illustration, and looking at it brings me back to that morning I was almost late to a doctor's appointment.

MILOU ON THE SUBWAY IN A BAG

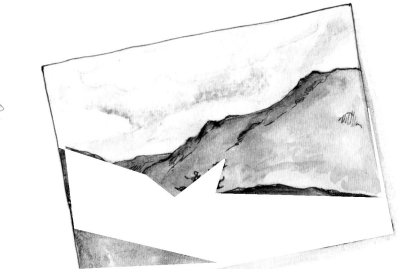

Once, I spent the afternoon with my sister in the little town where her painting studio is located. We are rarely able to spend time together, and were deep in conversation about how the area around Philadelphia has changed; it lacks some of the charm that I remember from years ago. At that moment we saw the sweetest wagon filled with pumpkins, and it occurred to me that the charm was actually still there, you just have to search for it. I had a desire to capture that moment in my journal, so I drew the wagon.

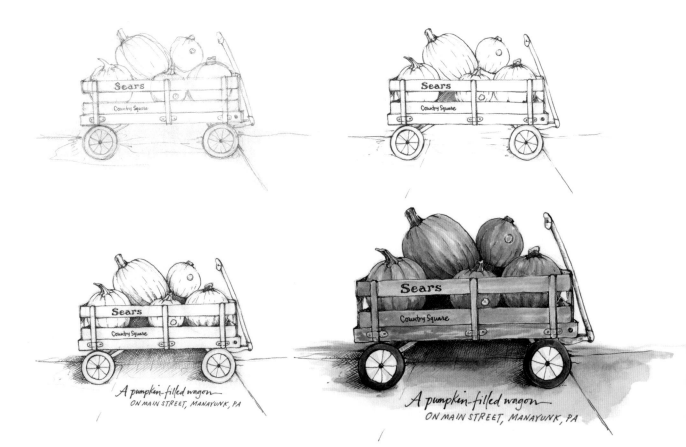

A pumpkin-filled wagon
ON MAIN STREET, MANAYUNK, PA

A pumpkin-filled wagon
ON MAIN STREET, MANAYUNK, PA

Here are some ideas for preserving moments and memories:

- Every year on my boys' birthdays, I draw a portrait of them. This is a personal challenge but also one of the most rewarding rituals I have kept throughout the years. I see how my boys' faces have changed and also how my skills and drawing style have developed.

- If drawing a portrait is too intimidating or just not your thing, there are many other ways to capture a child's milestones through a drawing practice. You can trace their hand, letter a list of their favorite things, or quote something he or she said. If you don't have kids, you can do the same thing for your partner, spouse, pet, or even yourself!

② Theo watching TV with Daddy

When something significant happens in your life, whether it be happy or sad, you can express your feelings through an art-making practice. Maybe you have lost someone close to you; there are many ways to honor your feelings of loss, and painting or drawing can help to ease the pain—or celebrate the joy of having known them.

Theo on October 26, 2019

Begin a Visual Tracking Ritual

Think of a ritual you have kept for a few years, or longer, or one that you wish to keep going forward. Perhaps you have already been keeping track of something for a while now but have not recorded it in a creative way.

A wonderful way to celebrate these regular routines and rituals is to create artwork that you can collect and look back on.

Here are some examples:

- On every vacation with your family, you buy a specific kind of souvenir. Draw the collection.

- On a special anniversary or birthday, you visit the same restaurant, or a different restaurant, each time. Draw the receipt so that not only can you track the location and ritual but also the change in price over the years.

- Do you keep a growth chart for your children? Re-create it on paper. We have one on the wall of our boys' room, and I always think how sad it will be if we ever have to paint over it or move. So I re-created it on paper and made a permanent piece of art.

- Do you have a favorite dress or coat that you adore but is frayed or doesn't fit the same as it used to? It might be time to part with it, but you can create a portrait of the garment that is frozen in time.

- Have your medications or vitamin routines changed? Celebrate the daily ritual and moment in time by drawing all of the pills, teas, or other forms of self-care items you consume.

- If a daily drawing ritual is too much for your schedule, try selecting a time of the week to capture one moment. Let's say it is Saturday morning at 10 a.m. Keep a dedicated "Saturday, 10 a.m." sketchbook or collection of paintings. How do you feel each week, what do you see, what are your plans for that afternoon or evening?

- Do you have a dedicated movie night? Or do you attend the theater regularly? Keep track of the movie or play you have seen each week by either drawing the poster or a scene from the movie or play. Or create an abstract piece that rates it.

Saturday, September 1st
LABOR DAY WEEKEND
a little girl with a bucket seen at
Girard Point at 10am

PAST AND FUTURE

So much of what I draw in my journal and in my work is a literal interpretation of what is in front of me. But some things I draw either remind me of the past or represent a vision for the future. Drawing from this point of departure can be artistically freeing and help you develop a personal style. It can also help you focus on important past experiences, appreciate the present moment, and/or speak to goals or desires. Going to a museum or gallery can often spark some of these feelings, or even all three at once. I can look at a painting and it will remind me of something I have seen in the past, which gives me feelings and ideas in the present moment that are so inspirational that I want to get right to work on achieving the next level for the future. Drawing the past and future can also look like a calendar or a written log. A fancy checklist, so to speak. Your lists can be on canvas, on paper, even on a series of notes pinned to your wall.

You can think back to your happiest moments, jot them down in a notebook, and then create abstract paintings titled as those memories. Or recall a very significantly sad or moving moment that you need to make artwork of, as a means to work through your feelings. I believe that the most moving work embodies an artist's emotional side. Drawing something just to draw it—or render in a photorealistic way to show off skill—is valid, sure, but this work lacks the emotion that I find a necessary part of an artist's work. And if bettering your realistic drawing skills is a goal, then find a way of incorporating the emotional as well as the rendering skill. Your work will be so much better for it. There are easy ways to combine skill and emotion, and the best way to tap in to these feelings is to look at your past—your children when they were young, a great love, a memorable trip, a profound accomplishment in your day job, or your desires for the future.

Pictured are some examples of how I have honored my memories of the past through my drawings of the present.

A dress like Mom Mom's

Last year while in London for a long weekend, I went into a dress shop recommended by a friend. As soon as I walked in, I thought of my grandmother and her homemade dresses. She made everything she wore. And all of her dresses were long, shapeless frocks, some fancier than others and always with a pocket. In my sketchbook I drew a dress of my grandmother's from memory alongside the dress displayed in the shop.

A few years ago, I saw a little boy running through the streets of Brooklyn Heights wearing a Superman cape. He reminded me so much of my younger son, who was obsessed with Superman at that age. I did not have a chance to snap a photo, as the encounter was so quick. But the memories from the past were so intense, I felt a need to capture what I saw the best way I could without the visual reference. I searched online for an image of a boy running taken from behind, used it as a rough guide, and added the Superman cape flowing in the breeze. I added the background of our neighborhood in Brooklyn using another photograph.

@ 11 am I see a little boy running in his superman cape and I feel a rush of nostalgia

I walked into a friend's painting studio, and the smell of oil paint and turpentine was overwhelmingly nostalgic for me. I grew up in my grandmother and grandfather's shared art studio and went to a fine-art school; I have encountered these strong smells many times in my life. They are so comforting and not at all intense to my nose, whereas to many people they are unpleasant. I illustrated a bottle of turpentine and the waves of odor blowing around it.

2·11·2020

Gum Turpentine

Drawing Your Past and Future

Below I have made a list to follow—or to spark your own projects. So often, nostalgic images and feelings can feed our current work and also inform what we would like for our future. Here are some ideas:

- Visualize your childhood home or room and draw it as best you can.

- Do you remember your first car? You can search online for images, draw your old car, and record any adventures and road trips you remember in it.

- Other childhood items—a favorite stuffed toy, your first pet, your favorite candy, an ice cream shop you visited regularly (even if it no longer exists, you can often find images of old shops online).

- Is there a dream project you would create, whether for work or for yourself? Maybe it's a series of paintings and a space to create them in, or a visual record of all of the places you have traveled. Maybe it's learning to play the guitar, or covering your bed in a quilt that you have stitched, or finally being allowed to take the lead on a dream project at work. Draw and/or write about these dreams and goals. Often if you put them down in your artwork you will feel more accountable.

- Is there something another kid once said to you in the playground that has stuck with you all these years? We know how much words affect us in our formative years. Write them down, and draw what you feel for closure.

- Do you remember your favorite books from childhood, teenage, or young adult years? Draw the covers.

- Do you have a recurring dream for the future? Something you see for yourself or your children? Record what you hope for, either through drawings or words. Our dreams and hopes can become more real and possible to us if we put them down on paper. You can reflect on these visual wishes for the future in later years.

- Write a letter to yourself about what you wish the next year to hold, and fold that page and close it with tape so you can read it a year later.

- Think of a difficult time you experienced, and use the energy and feelings to create a piece of art. It's okay to have sadness or anger be a focus. How can we truly draw our world without recognizing the hard times? And making an expressive piece of art can be healing. You might choose to think about a bad breakup. At the time it might have felt like your world was shattered, yet reflecting back you realize that no matter how awful it felt, you wouldn't be where you are today without those transformative experiences. Write about your memories, draw yourself emerging as new, then draw what you would love to see in your future.

- Create a drawing for your future self. Draw something you dream will happen in a year's time, and hide it away in a place you will discover later on, or in a place you know you will come back to in a year. Or mark your calendar to retrieve it one year from the day you created it.

- Make a beautiful illustrated list of all the places you wish to travel to, and work on your lettering.

- Play with composition. Close your eyes and think of a story from the past. Divide your page into four to six sections, using boxes or circles or various shapes, and in your own style, tell the story of the future within them.

- Draw a self-portrait and add some age. My kids play with apps on their phones that transform a photograph from today into an aged version of the person. Instead, try doing this on paper. How do you see yourself in ten or twenty years? Paint yourself with gray hair.

URBAN SKETCHING AND PLEIN AIR PAINTING

Back in 2017, I decided to make a series of paintings in my journal of some of my favorite New York City storefronts. Having no influence from the Urban Sketchers movement (in fact, I didn't even know about it at the time), I made my own rules, and they were very simple: I needed to encounter the location in real time and draw what I saw from my own height and perspective, perhaps using reference photographs. Often, I would make a point to visit a location, but other times I just happened to pass by a shop that I was drawn to, and decided in the moment to include it in the series. At the time, a few people suggested places (I think I even asked for suggestions on one Instagram post), but if I knew I was not able to get there and see it in front of me, I would not be able to include it in the series. The whole idea was consistent with my daily journal practice, and therefore the storefronts needed to be an authentic part of my day. In order to complete the drawings, I would sketch on location if I had the time and the materials with me. But I always followed up by taking photographs on my phone, and I would complete the paintings in my studio or at home. This series did not fall under the plein air or Urban Sketchers categories. My practice and series fell somewhere in the realm of both but did not follow either by strict definition. I learned this after talking to some amazing plein air painters that I have been lucky enough to meet through an event organized with the New York Botanical Garden. I have taken part in this event for three years now, and it has opened my eyes to a practice that I am in awe of and hope to challenge myself to do more often.

BOWNE & CO. PRINTERS
and STATIONERY SHOP on Water St
SOUTH ST. SEAPORT, NYC

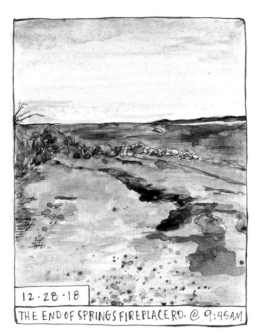

12·28·18
THE END OF SPRINGS FIREPLACE RD. @ 9:45 AM

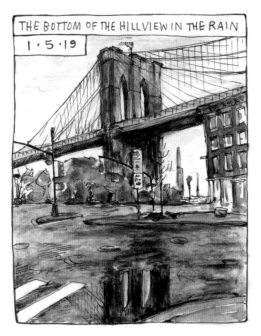

THE BOTTOM OF THE HILLVIEW IN THE RAIN
1·5·19

Here is the breakdown for both kinds of art. En plein air, or "in open air," painting became popular in the nineteenth century among the Impressionists because, by then, materials could be taken outside of the studio. Artists were able to sit in the fresh air and paint in real time on small- or medium-size canvases. These landscape artworks are stand-alone paintings that encompass light, perspective, and color seen in the moment. Urban Sketchers is a more recent movement organized by a journalist and artist named Gabriel Campanario in 2007. The movement has gained a huge following and popularity on social media because it is very much focused on community—a community that works on location in organized groups, supporting and encouraging the work online and in real time. Urban sketching is similar to plein air painting, but the works created are more gestural journal entries. There is often a bit of writing or description included in the work, from the time of day or location to more elaborate notes on

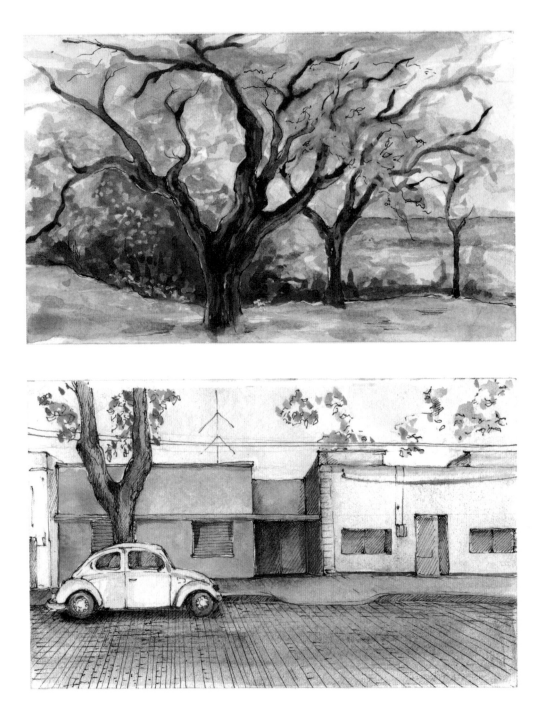

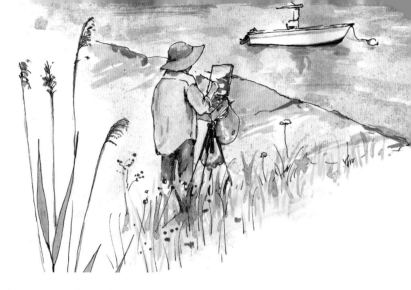

materials used or a story about the history of the building and so on. Another difference is that indoor real-time drawings (such as in a café) are also considered urban sketching.

Do I care that my project did not fall under these specific categories? Not at all. But I am happy to know the difference and can certainly respect the skill and work that goes into painting on location, with varying distractions, changes in light, cars, and people getting in the way.

It is up to you which term, if any, you would like to apply to your sketches or paintings created in real time. And it is important to know that you don't have to live in a city to develop an urban sketching practice. In my opinion, the idea is to be out in the world among buildings, houses, shops, crowds, people, trains, buses, and cars, and to capture the environment with quick lines and gestural drawing techniques, or to create finished outdoor scenes. The benefits of working among daily life are invaluable, improving how you see and practicing all of the things I wrote about in the beginning of this book— perspective, symmetry, light, and shadow. It is sometimes humbling to sketch on the spot, but the quick lines help loosen us up and help us to flip pages faster without getting too caught up in our mistakes. And once you feel you have grasped the scene, you can switch to a more finished plein air piece.

Another challenge and benefit to working on location, outdoors, or in public spaces is getting past performance anxiety. I have learned that about ninety-five percent of the time, people do not care or pay any mind to what I am doing when I am drawing in public. Occasionally, someone will ask to look at my sketchbook, and over time I have grown to welcome the exchange. I still have many days when I want to hide what I am doing because I am not thrilled with the work or it is in a state of the process that I know will improve. It can feel like you are under a spotlight working in a public setting, but if you learn to breathe through the fears and imagined judgments, and ignore the people around you as you create your sketches, you open yourself up to the opportunity to create beautiful work.

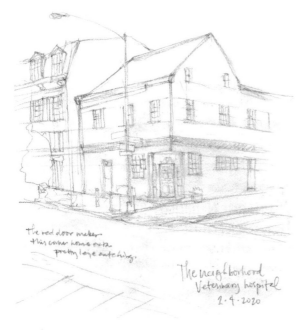

The red door makes
this corner house extra
pretty eye catching.

The neighborhood
Veterinary hospital
2·4·2020

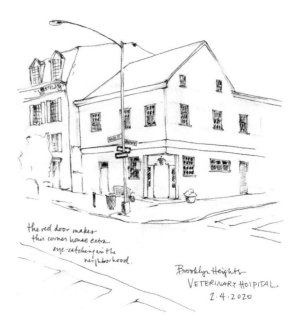

the red door makes
this corner house extra
eye-catching in the
neighborhood.

Brooklyn Heights
VETERINARY HOSPITAL
2·4·2020

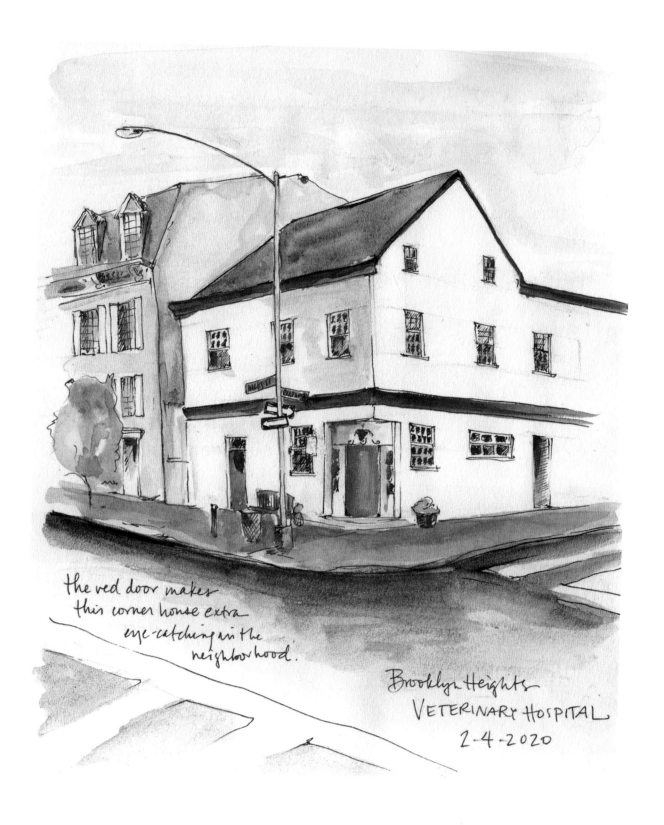

the red door makes
this corner house extra
eye-catching in the
neighborhood.

Brooklyn Heights
VETERINARY HOSPITAL
2-4-2020

Create an Urban Sketch

The best way to get comfortable drawing the outside world is to simply begin by finding locations you are comfortable and familiar with, so you can come back to draw them again. In an urban or more crowded area, you might find a favorite bench to sit on. I always find it helpful to draw the same scene a few times. You will see things a little differently each time, your perspective will improve, and you have the benefit of reviewing a series of work, tracking light at different times of the day or changes in foliage, and, most important, seeing your improvement over time. I suggest having a pencil, a few fine-line pens, and either colored pencils or a small set of watercolors with you if you can settle in long enough to paint.

Before you begin, take a few photos using the camera on your phone so that if there is not enough time—or you simply wish to—you can finish your piece later. It is also a good idea to take some reference photographs in case something obstructs your view or a person in your scene moves.

1 Choose a location and a time when the weather is mild and find a comfortable spot to sit for a little while, a place where there are not too many moving parts, cars, or people.

2 Begin by looking. This step should take a bit of time. Look at the light and the whole scene around you. You do not have to draw everything you see, and you can capture some parts in less detail than others.

3 Once you have decided on an angle and a section of your view to focus on, start by making a few marks to block off areas, then begin to create a horizon line and some guidelines on perspective as you see fit, keeping in mind that the degree of exactness is your choice. The idea is to sketch lightly, and as you decide where your lines will be, you can add weight and heavier marks.

4 As you develop your drawing, make some notes in the foreground or along the edge of your page recording the date, time, and location.

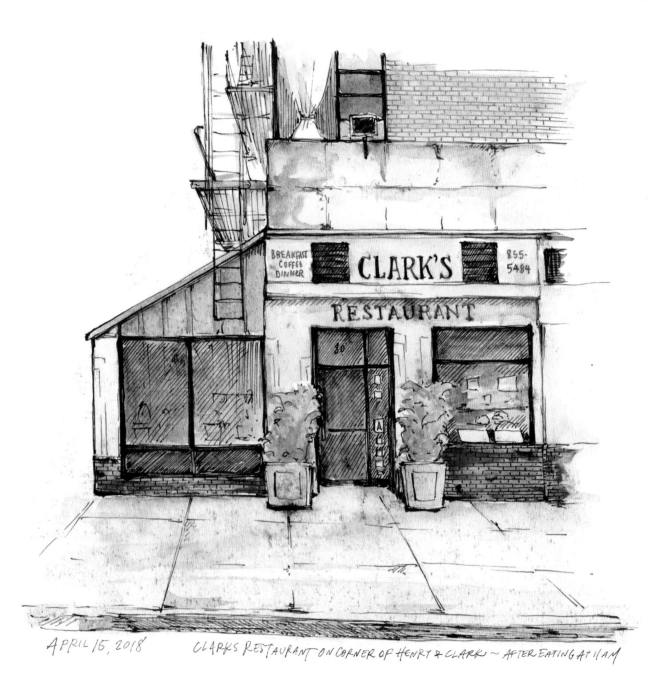

APRIL 15, 2018 CLARKS RESTAURANT ON CORNER OF HENRY & CLARK ~ AFTER EATING AT 11 A.M.

Create a Painting en Plein Air

The steps to beginning this challenge do not differ very much from the urban sketching challenge (see page 116). The difference is that, traditionally, plein air paintings are created in a more rural setting with a clear horizon or a whole field of the natural world. Maybe you set up near a lake with a docked boat, or in a garden, or at the beach. Be sure to bring your paints and your sketchbook, or even a small canvas or fine paper that is clipped to a board (so that the wind won't blow it at a crucial moment when you are just laying down paint). Often you will see plein air painters set up for a good half a day, usually with a travel easel so that all of their materials are in a tray right under their work and they can paint standing up. There are also inexpensive portable stools that fold up and are very light to carry. As with any painting practice, try a few small plein air paintings in a sketchbook at first. If you love the practice, then you can research and invest in all of the supplies you will need.

1 Choose a location and a time when the weather is mild, and find a comfortable spot to sit for a little while: a location with a vista or some water, or trees and a horizon line, or a landscape.

2 Begin by looking. Again, this step should take a bit of time. Look at the light and the whole scene around you. You do not have to draw everything you see, and you can capture some parts in less detail than others.

3 Once you have decided on an angle, and a section of your view to focus on, start by painting the horizon line and begin to build color around this line. Notice how the light may reflect on the water. Or how the blues in the sky change closer and farther away from the horizon.

4 This is your painting, so feel free to make it more or less identical to what you see. Use broad brushstrokes or fine crosshatching in ink. It is up to you. The key is to work from life and capture the natural scene in front of you in real time, in the fresh outdoors.

NATURE

What is the first thing you remember learning to draw? I believe many of us began to draw flowers around the time we learned to write our names. A simple flower is one of the most calming and joyous things to doodle, and there is truly no wrong way to draw a flower, nor is a flower ever ugly. From a crude childlike doodle to a finely rendered botanical illustration, flower pictures are always beautiful. "There are no straight lines or sharp corners in nature," Antoni Gaudí famously said. Allow this organic, free-flowing spirit to infuse your practice so that drawing the natural world should feel as freeing as it was when we were a little kid.

Whether your goal is to master botanical illustration or to create abstract works that only have the suggestion of leaves or the ocean, using the natural world in your work is integral to drawing your world. Even in your darkest work, a natural element can remind you as the artist—and the viewer—that all we experience on this earth is surrounded by, shaped by, and simply is the natural world, and therefore beyond our control. Leaves, flowers, trees, animals, landscapes, clouds, the weather, botany, rocks, fossils, the human body—whether you live in the city as I do or in the country, nature is everywhere. Similarly to subjects that are always available, such as food, a glass of water, or your clothing, if you want to capture your world through your artwork, there is no shortage of, nor avoiding, the natural world around you. Not only is it unavoidable, drawing nature is extremely beneficial to any artistic practice because it fully exercises your understanding of line, depth, scale, perspective, shading, and color. A simple leaf can provide you with hours and hours of drawing practice and is an education in and of itself!

There are endless tutorials and books on botanical illustration, and understandably so. Flowers lift our spirits and are beautiful to look at, so many of us want to master drawing them, either in our own unique way or exactly as they are, in a scientific rendering. They are often symmetrical and filled with repeated patterns, so adding them to our practice is a no-brainer! It is incredibly gratifying to be able to draw a petunia or a rose that looks just like a petunia or a rose, but there is also plenty of room for exploration and imperfection. Often the desire to render different leaves and vines and flowers is heightened simply because these subjects make us happy, and because the subject matter is less intimidating than, say, humans or architecture.

IN NATURE NOTHING IS PERFECT
AND EVERYTHING IS PERFECT.
Trees can be contorted, bent in weird
ways, and they're still beautiful.

—ALICE WALKER

The petals of a flower or leaves on a vine can fill space in your work with pattern and color. You can be inspired to draw a leaf just as you see it, but then paint it blue or gold instead of green. You can add petals of a flower or leaves to anything you draw. You can draw the shoes on your feet and then decorate them with a floral pattern. You can draw your pet sitting in a bed of roses. Or you can paint abstractly using the same green colors you see in the leaves around you. Or even paint a building using the colors you see in nature. Or illustrate the leaves you see creeping out of the concrete on the city streets. In this space, interpreting and deciding how to draw your world, anything goes. How freeing is that?

Aside from flowers and leaves, think of other ways the natural world can inspire your artwork. Look at the forms you see during a walk in the park: not only the leaves and flowers but also the rocks, the trees and branches, the dirt, the roots, the insects, the birds, or even the worms below ground. These shapes and forms can inspire an abstract work. Or you can choose to collect a handful of shells on the beach and illustrate them in a pattern. Think back on pencil lines in the first section of this book, where I discussed playing with pressure to create beautiful line work. Put that into practice when drawing leaves, petals, branches, and other elements in nature. Try using your paints with a slightly larger brush so that you can create gorgeous strokes, pushing down delicately and lifting up as you paint the stem of a flower. Fill your whole page or canvas with a solid field of color and then paint or draw on top of it, layering the colors.

The beauty of drawing nature is that there is such a wide range of possibility. Flowers can be so lovely when drawn using scientific or botanical techniques—or in basic forms like we drew when we were children. I explore every way in my own work; see the three examples at left, from childlike flowers to looser and more abstract renderings to a more exact representation.

in Red Hook ~ December 6, 2018

Flowers and grasses outside of the health food shop in the Springs.

Flowers and grasses outside of the health food shop in The SPRINGS~

Flowers and grasses outside of the health food shop in The SPRINGS~

Flowers and grasses outside of the health food shop in The SPRINGS~

Here you can see four stages of a drawing that highlights the grasses and flowers I saw as I walked into a food market. I love the colors and this simple nature-filled moment.

One Leaf or Simple Flower Three Ways

I think you have learned by now that I find repeating subjects multiple times and in varying techniques quite valuable. I invite you to draw a simple leaf or flower in three styles and choose which one you like best. This exercise will not take long, and you may enjoy the process of one over the other. But try all three. This challenge will help you truly see your specimen of choice with more patience and understanding. Before you begin, select a flower or leaf or a flower with leaves on its stem. I suggest choosing something that is fairly simple, not too intimidating. We will call it a plant specimen.

1 Make a quick line drawing of your specimen, taking less than a minute. Try drawing it without lifting your pen or pencil from the page.

2 Create an abstract expression of the leaf in whatever style that comes to you. Maybe you mix the colors of the leaf with your paints and make bold, thick lines, or maybe you work with a fine-line pen to create the outline of the leaf and then fill it with unrelated abstract patterns.

3 Spend time drawing the leaf, as closely as you can, in a way that captures it literally, exactly as you see it. Here you will put into practice all that we've spoken about previously. Line, proportions, and perhaps perspective. Look at the parts of your specimen as shapes that relate to one another. Notice how much space the flower at the top, for example, occupies in relation to the stem.

4 Now consider the three drawings. Which one are you most proud of? Which one brings you the most joy?

TODAY I HAVE A
COLD SO I STAY AT
HOTEL AND REST AND
DRAW. EVERYONE ELSE DRIVES
TO THE FINCA AND TO THE, PLACE
WHERE CECIL'S PARENTS ASHES ARE
SPREAD. IT'S HOT AGAIN AT 93F°
I AM A BIT SAD TO MISS OUT ON SEEING
MORE IN THE AREA. December 30, 2019

TRAVEL

For many of us, travel is our most sacred time, the time that we spend hours planning and days dreaming about before packing our bags and heading to the car or to the airport. We save our vacation days at work, set aside money, and carefully pack, anticipating a time to refresh ourselves, and discover new places and cultures. It's a time we can actually sit with a book undisturbed, or spend extra time writing, photographing, and sketching. My favorite time of any given year has been when I am traveling with my family. We connect on a deeper level, learning and growing together. We talk and laugh more, and we listen better without the distraction of school and work. Some days are hard, with lack of sleep on the travel days, packing incorrectly, language barriers, navigating the streets, and arguing over the next meal. Through it all—from the jaw-dropping monument to the mundane searching for an open pharmacy at 1 a.m. to get Benadryl for my son's allergic reaction—I have a deep desire to record *all* the experiences. I am filled with inspiration, and I want to draw everything. Some trips are jam-packed with events, so it's difficult to make the time to draw and paint as much as I would like to, but I make mental notes, jot small things down on my phone or in my journal. I take tons of reference photographs, and I am constantly asking my boys to remind me of the names of places and help me replay events so that I can draw them later. When we travel, my practice becomes more of a family affair, and the artwork and recorded memories in my journal are a gift to all of us as we look at them later on, bringing us back to those precious moments.

Whether you are keeping a travel journal or making a series of small plein air paintings, there is never a better time to have an art-making practice than when away from home. You have already set aside the time to explore, relax, and see new things, so you should find a calming way of preserving some of those memories on paper. Leading up to your trip, you can use your journal as a space to build excitement and prepare with lists and maps, but you can also use it as a place to set an intention for the practice you wish to maintain while away. Keeping a sketchbook or sketch journal helps you slow down and really take in all that you are seeing and doing with new perspective. While it's a practical space for thoughts, names of places, and contacts, it is also a perfect creative outlet. In fact, the art-making practice that we develop while traveling can tie into most sections of this book—preserving moments in time, urban sketching, honoring the present and the past. Maybe you are revisiting a location you have not been to in years, or you are able to enter a deeper meditative mind-set in the present moment. Travel opens the eyes wider; we literally see more because we are looking for anything and everything different to take us away from our routine. I believe I am just a touch more talented as an artist when I am being inspired by travel, simply because I am more relaxed and open. The work you create with less stress and pressure will inevitably be freer and lighter, and that really does come across on the page.

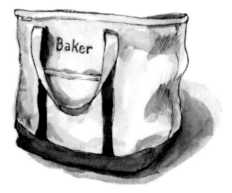

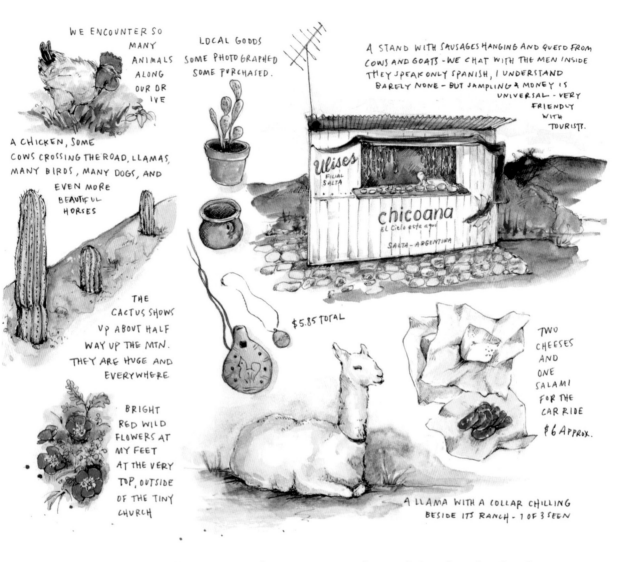

WE ENCOUNTER SO MANY ANIMALS ALONG OUR DRIVE

A CHICKEN, SOME COWS CROSSING THE ROAD, LLAMAS, MANY BIRDS, MANY DOGS, AND EVEN MORE BEAUTIFUL HORSES

LOCAL GOODS SOME PHOTOGRAPHED SOME PURCHASED.

A STAND WITH SAUSAGES HANGING AND QUESO FROM COWS AND GOATS - WE CHAT WITH THE MEN INSIDE THEY SPEAK ONLY SPANISH, I UNDERSTAND BARELY NONE - BUT SAMPLING & MONEY IS UNIVERSAL - VERY FRIENDLY WITH TOURISTS.

Ulises
FILIAL SALTA

chicoana
El Cielo esta aqui
SALTA - ARGENTINA

THE CACTUS SHOWS UP ABOUT HALF WAY UP THE MTN. THEY ARE HUGE AND EVERYWHERE

$5.85 TOTAL

TWO CHEESES AND ONE SALAMI FOR THE CAR RIDE $6 APPROX.

BRIGHT RED WILD FLOWERS AT MY FEET AT THE VERY TOP, OUTSIDE OF THE TINY CHURCH

A LLAMA WITH A COLLAR CHILLING BESIDE ITS RANCH - 1 OF 3 SEEN

As you can see from my own travel artwork, I tend to take a lot of notes. I choose to create a drawing practice around my journal so that I not only remember visuals but also have a place for names of restaurants and other details that I might otherwise forget. I have a good visual memory, but it is very hard to remember street names or hotel names years later. Above are a few examples of the works I've created while traveling with my family.

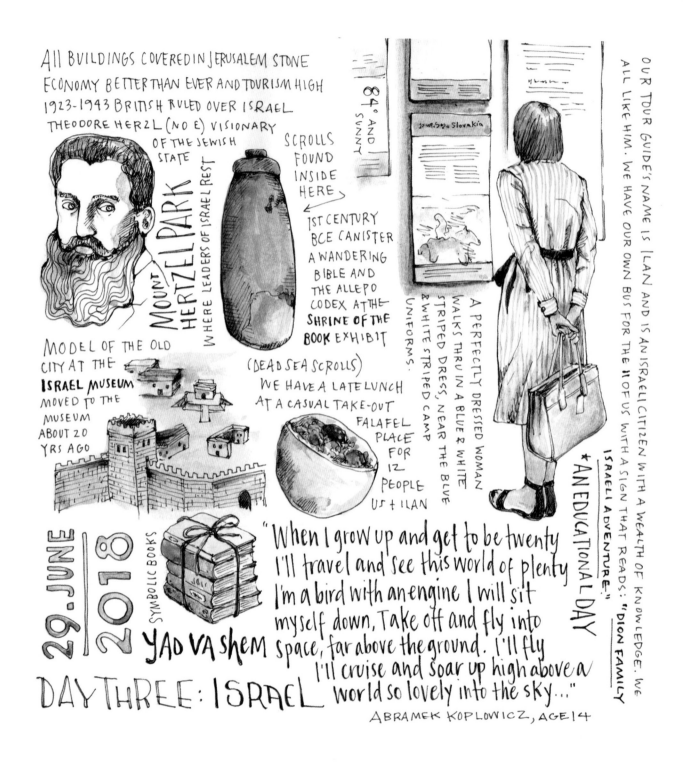

ALL BUILDINGS COVERED IN JERUSALEM STONE
ECONOMY BETTER THAN EVER AND TOURISM HIGH
1923-1943 BRITISH RULED OVER ISRAEL
THEODORE HERZL (NO E) VISIONARY
OF THE JEWISH STATE

MOUNT HERTZEL PARK
WHERE LEADERS OF ISRAEL REST

SCROLLS FOUND INSIDE HERE →
1ST CENTURY BCE CANISTER
A WANDERING BIBLE AND THE ALLEPO CODEX AT THE **SHRINE OF THE BOOK** EXHIBIT
(DEAD SEA SCROLLS)

84° AND SUNNY

OUR TOUR GUIDE'S NAME IS ILAN AND IS AN ISRAELI CITIZEN WITH A WEALTH OF KNOWLEDGE. WE ALL LIKE HIM. WE HAVE OUR OWN BUS FOR THE 11 OF US WITH A SIGN THAT READS: "DION FAMILY"

* AN EDUCATIONAL DAY *
ISRAELI ADVENTURE."

A PERFECTLY DRESSED WOMAN WALKS THRU IN A BLUE & WHITE STRIPED DRESS, NEAR THE BLUE & WHITE STRIPED CAMP UNIFORMS.

MODEL OF THE OLD CITY AT THE
ISRAEL MUSEUM
MOVED TO THE MUSEUM ABOUT 20 YRS AGO

WE HAVE A LATE LUNCH AT A CASUAL TAKE-OUT FALAFEL PLACE FOR 12 PEOPLE US + ILAN

29 JUNE 2018

SYMBOLIC BOOKS

YAD VA SHEM

DAY THREE: ISRAEL

"When I grow up and get to be twenty
I'll travel and see this world of plenty
I'm a bird with an engine I will sit
myself down, Take off and fly into
space, far above the ground. I'll fly
I'll cruise and soar up high above a
world so lovely into the sky..."

ABRAMEK KOPLOWICZ, AGE 14

On this sketch journal page, opposite, I captured many things and wrote a lot of words. I wanted to remember so many details while we were in Israel because it is such an education to be there. When we visited the Holocaust Museum in Jerusalem, I noticed that a woman was wearing a blue-and-white-striped dress, commemorating the blue-and-white-striped garments worn by Jews at Auschwitz. I felt this was such a poignant visual that I wanted to preserve it through illustration.

On family ski trips, I prefer to sit by the fire and draw while my husband and boys ski. This is a painting of my kids just as they finished a ski run, seen from inside the lodge.

When traveling, I always spend time at art museums. On this day, I drew some of the female faces seen throughout MoMA's permanent collection.

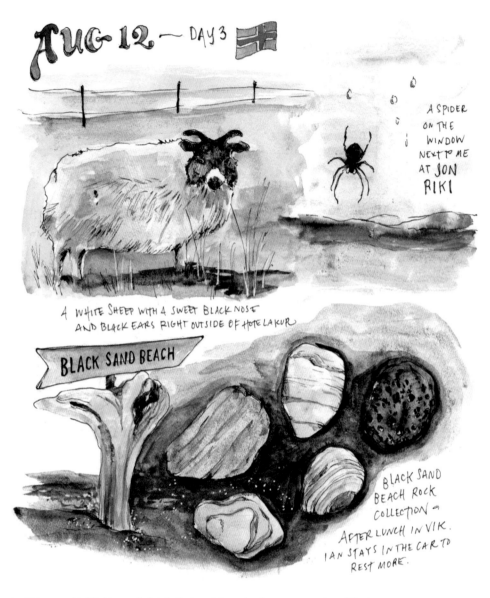

AUG 12 — DAY 3

A SPIDER ON THE WINDOW NEXT TO ME AT JON RIKI

A WHITE SHEEP WITH A SWEET BLACK NOSE AND BLACK EARS RIGHT OUTSIDE OF HOTEL LAKUR

BLACK SAND BEACH

BLACK SAND BEACH ROCK COLLECTION → AFTER LUNCH IN VIK. IAN STAYS IN THE CAR TO REST MORE.

This page highlights small details that explain and enhance memories of the larger, more monumental things we saw and experienced on our trip to Iceland. First I had to illustrate a sheep, as there are about three and a half sheep for every human in Iceland and they roam freely everywhere. We found a restaurant in a more secluded area during our drive along the ring road (the road that circles the whole country). There was a spider right next to me on the restaurant window and I made a note to remember the restaurant name. Last, I illustrated the rocks we found on Reynisfjara, the black sand beach. These smaller moments captured through illustration bring me right back.

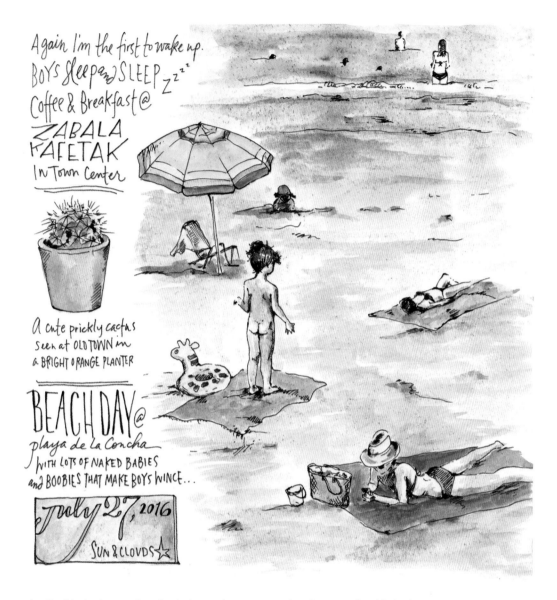

Again I'm the first to wake up.
BOYS SLEEP SLEEP Zzzz
Coffee & Breakfast @
ZABALA
KAFETAK
In Town Center

A cute prickly cactus
seen at OLD TOWN in
a BRIGHT ORANGE PLANTER

BEACH DAY @
playa de la Concha
with LOTS OF NAKED BABIES
and BOOBIES THAT MAKE BOYS WINCE...

July 27, 2016
SUN & CLOUDS ☆

On this day I remember clearly that my boys were made quite uncomfortable by the nudity on the beaches in Spain. A small girl standing ahead of us was so sweet I took a few quick snapshots on my phone and drew her when we sat down to dinner. Because she was little, the boys approved of my drawing. This page highlights just one scene, but I can recall so much more when I look back at it.

Travel Exercises

The following exercises can really be done anytime you choose; I just
happen to find more inspiration for ideas when I am away, so these
are taken from my own past sketch journal and travel artwork. They
are meant to spark your own projects. Feel free to skim through and
see if one catches your attention. Or have fun using them all!

RAFTING, DEERFIELD RIVER, MASS.

- Set aside a small canvas, surface, or sketchbook page for each day
 that you are away. Try to fill that space with some expression of
 the day's events, whether it is color and collage or the details of
 each hour. Some days will be very tight on time, and that's okay.
 If you do not have the time, make it a very quick gestural sketch
 that you can re-create at a later date. The idea is to do this drawing
 or painting in the moment. You might remember details later, but
 in the very moment of travel, our senses and feelings tend to be
 heightened and more emotional.

- Ask every member of the family or your travel mates to tell you
 their favorite part of the day, and jot it down so that you can
 keep the notes as a memory. And if you have the time, or if you
 feel inspired, draw each of these highlights. Or have the members
 of your group draw their own highlight in their own style, and
 collage all of the pieces together to make one final piece of art:
 a true collaboration.

MARKETS IN OLLANTAYTAMBO, PERU

- Trip games are fun if you are planning a very long travel day.
 Sometimes the path to arriving at your destination can be
 extremely tiring and sometimes a bit boring. Setting up a game
 with yourself or with your family or travel mates can help the time
 pass. I have counted different license plates with my kids on long
 road trips, jotting down the name of each state as we found them.
 Later on, you can draw each of the state license plates by a simple

Google search. Or how about illustrating the signage you pass? Or the view from the window in motion. You can snap photos each hour, and re-create the movement and scenery on paper.

- Collect all of your receipts and ticket stubs throughout your trip and make a collage with them. You can draw them or glue them down. Or you can glue an envelope (I like to use hotel stationery envelopes) to enclose tickets or packaging or business cards right in your travel sketchbook.

- Challenge yourself to spot one thing each day that you have never seen, eaten, heard, or felt before. Record your "new" experience in a consistent fashion, whether in its own painting or in a small box in the corner of each day's journal entry.

- Think of a unique way to capture a great meal, whether it be through a drawing, writing out the item you ordered as it's listed on the menu, drawing the street signs on the corner where the restaurant is located, drawing the restaurant's logo, or collaging a portion of the restaurant's business card onto your artwork.

- Choose a spot that you find inspiring and visually beautiful or interesting—somewhere that really feels like a location you are seeing for the first time. As you stand there, look straight down and take a snapshot on your phone or camera, look up to the sky and take another snapshot, look in a window, look in the shops, look to your left and look to your right—take five to six photos total. Choose three to four things to draw from that one single spot. You can mark the location and date on your artwork.

- Find a location (ideally a landscape) that is easy to come back to at different times of the day; a scene from your hotel window is a great example. Draw or paint the landscape first thing in the morning, again when the sun is setting, and a third time at night. Present the series as a triptych (a series of three paintings that are meant to be viewed as one).

Day in the Life—or a Travel Day in Five Parts

Our travel challenge can be done any day of the year. I find breaking down a travel day into parts is very helpful as I organize my thoughts and what I would like to remember. You can do this to document a short road trip or a month abroad. It is an easy go-to exercise. I have suggested five parts, but feel free to break down your page into as many parts as you would like.

1 As you go through a day on a trip, take mental or physical notes of five things in a small pad or on your phone. Select your five things from big to little in scale, and from extraordinary to mundane. For example, think of a sandwich you had for lunch, a mountain, or a famous painting at a museum. It is a good idea to take some snapshots if you feel you may need visual reference.

2 When you have the time to sit down and create, divide your work surface or sketch journal page into five uneven sections.

3 Begin to sketch your five memorable moments with a small caption for each so that you remember why you selected it. Some will be obvious and may not need as much of a description, whereas others may require more of a story.

4 You can finish your piece at any time, but the idea is not to wait too long to create your initial sketch. After time passes, we don't remember why we selected the smaller or seemingly less significant moments. But they are so important for preserving our memories.

I urge you to take some time, on any trip you take, to get lost and just wander. Spend a moment with a local, stroll down a road that takes you off course on your way to the next tourist attraction. This way you can draw or paint a little bit of both the planned and the unplanned: for example, the Great Wall of China and an awkward moment of communication with someone who does not speak your language. It is in these moments that you will encounter the unexpected, and this will feed your creative practice. Safety is important, of course, but there is always a chance to go off course, stray from your itinerary in some small way, so that your planned experiences are framed by spontaneity and surprise.

EVERYDAY LIFE

In 2018, I started working in a studio space outside of our home. And while it has been transformational for my work, it has also given me less of an opportunity to explore. I used to need to escape my little home office, so I would work in cafés or on a garden bench, seeing all the diverse people, animals, and things that New York City has to offer the eyes. But now I open my studio door and look at the same things each day. So the "just draw what you see" advice I gave in my first book I have now learned, firsthand, can be a challenge! I make the time to get outside for lunch or for a meeting, so that I can experience things such as petting a neighborhood puppy or finding a Polaroid on the ground or getting an errand on my to-do list out of the way. But as I have suggested to students and readers, I also simply draw what's in front of me, some things over and over again. It has only helped my skills on perspective and color and light, and now I have more objects mastered. I can draw a paintbrush and a book in perspective pretty easily. I practice drawing my hand or my hand holding things. I practice more handwriting styles. I do whatever I need to do to feel I am strengthening my drawing muscles.

Another huge benefit of drawing everyday life is the celebration of the mundane; the repeated, everyday street signs; and neighborhood encounters. Do you get your coffee from the same café each morning? How can you create a series of work that reflects the repetition of certain activities? Is there a corner you turn each day, or even multiple times a day? Are there pills or vitamins that you need to take in a specific order, day after day? Do you relish routine, or do you have a hard time keeping up with daily to-dos? Some of the most successful art projects are series that celebrate the ordinary. The idea is to explore all of the ways we can be creative on the boring days, sick days, or days we need a lift.

In fact, celebrating the ordinary and coming up with a series of artwork based on the things we see, do, or eat every day can take all of the pressure off. My great-aunt was a painter, and she created still lifes using the same subject matter day after day. She did not get tired of painting her pottery, pitchers, tea tins, and bowls of fruit. She did not exhaust this subject matter because she would mix up the compositions, sometimes having the objects bleed off the sides of the canvas, other times playing with elements creeping farther into the foreground. If you think about it, four or five objects can be painted in thousands of ways.

A Polaroid found on the sidewalk on my walk to my studio.

When leaving a department store in Philadelphia once, I noticed the small plaque on the revolving door as I pushed my way through. It was really striking, and I immediately thought of all of the people who had pushed through the same door before me, never noticing this small bit of history and design right in front of their hands. I snapped a photo so that I could draw it later in my sketchbook.

Keep an eye out for small details. The more you open your eyes to them, the more you will see. I imagine that many of us pass by beautiful details every day, year after year, without noticing them. The ordinary can be so beautiful if you take notice and draw!

A Revolving door plaque in Philadelphia

A Revolving door plaque in Philadelphia

A Revolving door plaque in Philadelphia

Small Items

Choose one small food item that you have around the house. A few nuts, raisins, black beans, blueberries, slices of a banana, or some M&Ms. Draw a border around your page or surface with a succession of these items in a random or more intentional pattern.

Details of a Walk

Take a short walk around your block or on a nearby street. Look carefully for a small detail that you have never noticed before. Or maybe something that you have noticed but that has never been of much interest to inspect. For example, a manhole cover or the doorknob to a local café. Take a reference photo or sketch it on location. When you get back to your workspace, try drawing it in more detail. What do you notice? Has this mundane, everyday subject perhaps become more interesting as you've attempted to draw it or celebrate it through your artwork?

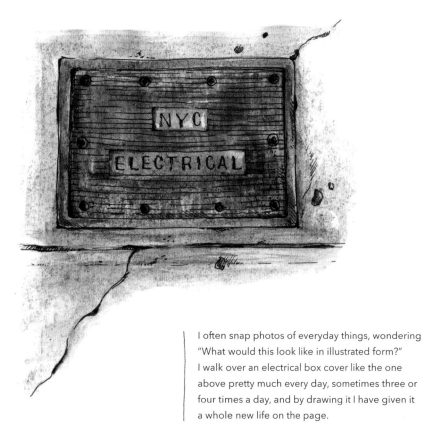

I often snap photos of everyday things, wondering "What would this look like in illustrated form?" I walk over an electrical box cover like the one above pretty much every day, sometimes three or four times a day, and by drawing it I have given it a whole new life on the page.

Dinner Ingredients

While cooking dinner, separate out any ingredients that are direct from nature: fruits, vegetables, raw nuts, wild rice. Anything that is unprocessed and in its original state. Before you begin to chop and dice, take a photo for reference. When you get a moment, paint or draw these ingredients. If it's not dinnertime, then set up a still life and paint or draw that. The foods we consume are beautiful inspiration and are an excellent subject, especially on the days or moments when we don't know what to draw.

Ordinary Small Items

Collect a handful of small items from your bag or around your home, things that can fit in the palm of your hand. Choose items that are mundane yet significant to your daily life: a thumbtack if you pin things up on a mood board, a hair band, a piece of gum, an earring, or even a pen nib from your art supply bag. Drawing something very small a bit larger, as if under a microscope, can help you tune in to all of the smallest details. Even the most ordinary things can become more interesting when singled out and drawn.

While a day may come and go, blending into the week, month, and year, it is still worthy of celebrating. Every moment has its own charm and beauty if you are open to seeing it. An ordinary stressful day may end with a really long, hot bath. Similarly, you can use your art-making practice to de-stress by choosing something small and inconsequential to focus on. I often tell students to choose a small object to draw over and over again. From a key chain to the changing sky above, the everyday can easily be your muse if you let it be.

from Vol. 2, no 2 (June 1927)
BK Historical Society
V. Wicht.

No 10 (Feb 1927)

IT IS
A MEDIU
COLD DAY &
NOT MUCH HAPPE
So I spend a little
more time in my
journal...

THE Brooklynite
Cards 15 cents
purchased
at THE BK HISTORICAL HISTORICAL SOCIETY
m is in California and
THE BOYS AND I WORK AT THE
DINING RM. TABLE FOR A HOT
SECOND IT'S CALM BUT THEN the
USUAL SCR-
EEN TALK

January 9th 2019

EXPERIMENTAL AND MULTIMEDIA

I believe experimental and multimedia art is one of the most important topics to discuss as you move forward with drawing your world, and I am sharing this chapter last for a few reasons. As I have mentioned in previous sections, I have mostly taught myself how to draw and paint over the years through trial and error. While experimenting, I sometimes find the rules a little distracting, so I consciously try to avoid traditional guidelines and techniques so that my work is a sheer carefree expression. I go with my gut, and I look very long and hard at the subjects I draw so that I can figure out the best way to translate them onto paper. Most often I am inspired to practice and draw things just as they are, but it is also fun to simply paint with colors inspired by my experiences or colors that I am attracted to at that moment. I know there is a benefit to having the knowledge, and I plan on deepening my understanding as I develop my own practice, but as I continue to home in on my personal style, I relish these moments of abstract play. It is so satisfying to illustrate three apples just as they are, but I am no more proud of the realistic pieces of artwork that I create than I am of the nonrepresentational work. Studying from the masters is important, but finding your own true vision can only come from your own experiments and mistakes. Sometimes the happiest accidents happen with free and expressive creative play, and this work can build and develop into an entire series. Getting out the materials and just having fun exploring all that they can do on different surfaces—blending, collaging, dripping paint, tearing papers—this is where the magic happens. Try the beginning exercises, such as blind contour drawings, in your work, or play with lines by pushing and pulling your brush or pen on and off the page.

From the very beginning of this book to the end, I hope to bring things full circle. You see, the lines you created with your pencil are just as much a part of you and your creativity as the work that you obsess over for hours and hours. Abstract work is incredibly freeing and beneficial in helping us to interpret the world around us and find ways to represent it. Here there are no rules. The practice can be completely freeing—free from judgment, free from any idea we have of perfection. You are still drawing the world around you; this is just a different expression of your feelings and experiences.

From building, overlapping, and mixing mediums to gluing down ephemera or torn papers to painting on top of photographs, I invite you to have fun experimenting. Here are a few examples of my own abstract work.

First, I drew some flowers I saw on wrapping paper in my mother's studio and painted light washes of watercolor in the background, filling the whole page with color. At the bottom I added a piece of washi tape from my collection that had a similar look to the washes of colors. I then added some light marks in ink.

Next, feeling inspired by my acrylic paints, I used my finger to cover the light washes with some more intense opaque colors, flowing down from the top of the page, echoing the cascading flowers on the left.

I created these small pieces one rainy afternoon while in my studio. I have had many paper samples sent to me over the years for various projects, and had saved this beautiful light-gray Fabriano paper. Using white gouache, some watercolor, and a black fine-line pen, I listened to some music and just had fun.

This collage brings me back to a moment with my son and it is a great example of using what's around you to create something interesting. All I had in the moment for a collage was the wrapper to a pack of Charms candies. I simply started by gluing down a few torn pieces, and the rest flowed from there, inspired by the bright colors and the fruit illustrations on the packaging.

My 11 year old has a candy addiction - he loves any kind and the more artificial, the better. We worry about his diet, yet somehow he finds his way and eats some daily.

It's raining today - and sunshine as of 11 am. The temp is colder so I avoid being outside. Mala & Dad & Ian are in Jackson Hole skiing - I am ready for Spring!

ASSORTED CHARMS

ASSORTED CHARMS ARTIFICIAL

CHARM

T and I eat some Charms at the airport

MARCH 26, 2019

COVINGTON/TN-380

CORN SYRUP, CITRIC ACID, ARTIFICIAL FLAVORS & ... RED 40, FD&C BLUE 1, TURMERIC COLOR ... MILK AND SOY MAY BE PRESENT ...

Nutrition Facts Servings:
Calories 25, Total Fat 0g
Added Sugars, 10% DV Protein
Vitamin D, calcium, iron and potass...

INGREDIENTS:
COLORS IN...

www.roots

0 149852

NV 1
(2

2 pieces (6g),

Experiment with Different Media

Have fun and make some abstract work to balance the harder work; free-play with your materials is so important.

1 Make a continuous line in light pencil, starting from one corner and filling the whole page. The line can be as long, curved, or angular, and fill the page as densely or sparsely as you choose. You can even close your eyes as you make your line. Or, better yet, make a blind contour drawing of a friend or an object and use that as a starting point.

2 You will notice that your line will create many shapes. Using this line as a starting point and filling in the closed areas or shapes with color, paint over some lines with opaque color, and fill other areas with light washes or colored pencil.

3 Trace a few of the shapes using a thin piece of paper or tracing paper. After tracing, you can hold the tracing paper over a colored paper, wrapping paper, kraft paper, or really any scrap paper, and cut out the shapes, making sure you hold the two pieces firmly so that they don't slip apart from each other.

4 Glue the cut shapes onto your artwork in the place where they appear.

5 Keep playing. Make it your own. The process is fluid and yours to push and pull and play with!

COLLAGE MATERIALS
(anything and everything!)

Here are some more ideas for you to consider:

- Did it rain or snow today? Make an abstract piece inspired by falling rain or snow. Splash watery paint on a piece of paper or surface. Cut out raindrop shapes from gray and blue papers, glue them down in a pattern, and paint on top and around them.

- Get out your palette of watercolors or gouache, and, using each color, paint a series of lines or circles until you fill your paper or surface.

- Find old magazines, advertisements, or old family photographs that are not precious and glue clippings of them down, painting color or pattern around them.

- Using your coffee mug, splash a little of your coffee on a plate and put the bottom of the mug in the puddle so that you can make a circle stamp of the bottom of your mug onto your paper or surface. Try painting a little bit with the coffee.

- If you have children around you to collaborate with, ask them to draw something for you, and build or enhance their art with your own abstract marks or lines. Or make patterns together on the page. Children are the most carefree when they are creating. Use that energy in your work. Have them make a line, then you make a line, and repeat until you fill your paper. Or, if they are older, make a collage journal page with them.

- Make a background of solid washes of paint and color lines. Then glue a drawing on top, framing it with your abstract work.

- Find one simple shape that speaks to you. A heart, a triangle, squares, diamonds. Create a collage repeating your chosen shape over and over, using various materials. Have some bleed from the sides. Make some of the shapes large and some very small.

- Find a piece of ephemera, an old photograph, or a ticket stub from an event. Glue it down and create an abstract painting or pattern around it.

This collage was created with my son, who was eleven at the time. We were having dinner at one of our favorite neighborhood restaurants, and I asked him if he would collaborate on my daily journal page. We each took turns adding to the piece, and it kept us busy as we waited for our food to arrive.

You might be surprised after reading a whole book about drawing that I am encouraging you to make shapes and color and pretty much . . . not draw. Or at least not make drawings that are literal but are more about expression and color. Of course, don't be fooled: it takes a lot of skill to create a beautiful, balanced composition even if you are just making marks and lines. You will still have to think about symmetry, fluid and pleasing line work, color, and composition. You might decide to make a series of paintings that have a full field of color or a background of striped watercolor washes. These can be the ground for a more realistic drawing or painting layered on top. Just explore and have fun and the ideas will come to you. I urge you to compromise and take part in a process that may feel uncomfortable at first. Let go of your goals and you will find that pressure for perfection is less of a burden as you explore your abstract pieces. I promise that this work will feed your whole creative process—and enhance your results.

CONCLUSION

How can you capture a walk in the park with blooming flowers all around? A sad day, or a frustrating meeting? Or feeling tired, or full of excitement? How can you create a body of work that is simply an expression of your overall state of mind in a particular week, month, or year? We have awful years and wonderful years. Your world does not need to be broken down into days or hours. Many artists create a body of work that encompasses a larger period of time, and then another, and another, and these collections are often completely different expressions. Sometimes it is hard to tell that certain bodies of work were created by the same artist. Just as times change, our inner world changes, and so can our creative practice. When you look at it this way, all art is an interpretation of the world around the artist. Activist or political artwork is an expression of the time; making art about falling in love is an expression of the moment; art used for healing yourself after a physical trauma is an expression of the moment. Or, full circle, illustrating your bowl of cereal in the morning is also an expression of a moment. And all of these experiences can be expressed on paper in any way you choose.

When we pick up any new hobby—or come back to a creative practice that we abandoned long ago—the road to a place of pride and confidence can be really rocky and frustrating. I have so many moments and days where I feel like my progress has leveled, or even regressed. It's part of life. If we begin at a place of perfection, then why keep trying? I understand it's hard to have something you've worked hard on stare right back at you and feed you with all sorts of unpleasant feelings. Unlike picking up music or a sport, with visual arts you have a physical record of your progress. In the beginning, looking at your work can make you feel embarrassed or like a failure, outweighing the feelings of pride. But eventually that balance shifts.

And trust me, it's worth putting in the time to get there. I hope that I have helped you to realize that the journey is yours, and can lead you to unexpected places. From the beginning of this book to the end, I hope you feel inspired to draw your world in a way that lifts your soul and enhances your creative spirit.

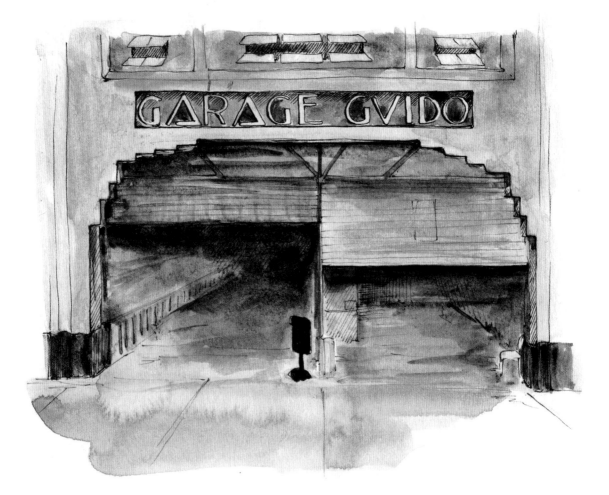

RESOURCES

Many of the items I list in the Tools and Materials section of this book (pages 10–23) can be purchased at Dick Blick stores (www.dickblick.com), but many can also be found at your local art supply store. The following are readily available, or can be researched and/or purchased through their websites:

PENS & PENCILS

Blackwing pencils
blackwing602.com

Caran d'Ache Supracolor colored pencils and Neocolor pastels
carandache.com

Copic Multiliners, nibs, ink cartridges, and original Copic Markers
copic.jp/en

CW Pencil Enterprise
cwpencils.com
The best resource for pencils. They carry a full range from hardest to blackest pencils in drawing sets, and they also carry my favorites, the Caran d'Ache Swiss Wood pencil and the Palomino Blackwing. They also sell the full range of Caran d'Ache Supracolor colored pencils that you can buy individually to build your own set, and have every eraser and sharpener your heart could desire.

Faber-Castell Pitt artist pens
fabercastell.com

Pentel Arts Pointliner
pentel.com

Pigma Micron fine-line pens
sakuraofamerica.com

Rapidograph
staedtler.us/en
Staedtler Mars plastic pencils, markers, and erasers

PAINTS

Case For Making handmade watercolors
caseformaking.com

Daniel Smith watercolors
danielsmith.com

Derwent Inktense Paints and Pencils
derwentart.com

Greenleaf & Blueberry handmade watercolors

greenleafblueberry.com

Holbein Acrylic Gouache

holbeinartistmaterials.com/designer-gouache-sets

**Winsor & Newton watercolor paints
and Series 7 brushes**

winsornewton.com

PAPER & SKETCHBOOKS

Arches Hot-Pressed Watercolour Blocks

arches-papers.com

Fabriano Studio Watercolor Pads

fabriano.com

**Moleskine Sketch Album in various sizes,
as well as Moleskine watercolor notebooks**

us.moleskine.com/en

Peg & Awl handmade journals and sketchbooks

pegandawlbuilt.com

Stillman & Birn sketchbook system

stillmanandbirn.com

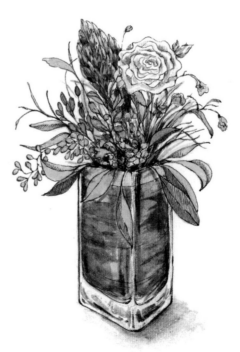

ACKNOWLEDGMENTS

To my grandmother Evelyn Keyser, who is with me in spirit, I am so thankful for your words and guidance that were a gift to me for so many years. I can still hear your voice so clearly, telling me how proud you are. And thank you to my parents, Deborah and Alan Dion, who continue to support everything I do, from being first in line to purchase my work to liking every one of my posts to offering to take care of my boys while I meet a deadline—I am so lucky to have you. To Fairley and Cecil Baker, whom I am so thankful for each and every day; to my sister, Joanna Brown—you are always my inspiration; to my girlfriends (you know who you are, and I am incredibly blessed to have your constant support, understanding, advice, and laughter)—you ladies get me through the days and I carry your words and love with me everywhere. Thank you to, hands down, the best literary agent, Laura Lee Mattingly, who knew I had a *Draw Your Day 2.0* book in me—once again, this book would not exist without you. To the entire team at Ten Speed Press and Watson-Guptill: Ashley Pierce, who edited the book with so much care and love and has become a friend through the process; Jane Chinn in production; Lisa Bieser, who made the book as lovely as it is; and a special shout-out to the incredibly talented Kaitlin Ketchum, whose confidence in my work and in me carried me through the entire process. To Ian and Theo, whom I have gotten to know even better through the pages of my sketchbooks—you are the coolest kids on the planet, and you are loved beyond measure. And last but not least, to my very best friend and guiding light, Malcolm Baker—thank you for loving me and letting me love you back.

ABOUT THE AUTHOR

Samantha Dion Baker grew up in Philadelphia in a family of artists. She graduated from The Cooper Union in New York City and spent over twenty years working as a graphic designer. Now a full-time author, illustrator, and artist, her favorite thing to do is wander the city streets and travel with her family, drawing in the pages of her sketch journal all of the things she does, eats, and sees. She is also the author of *Draw Your Day* and *Draw Your Day Sketchbook*. Her self-published daily sketch journals are in the permanent collection of the Morgan Library & Museum exhibited at The Metropolitan Museum of Art. She lives and works in Brooklyn with her husband and two sons.

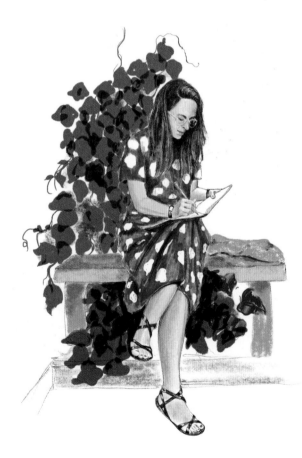

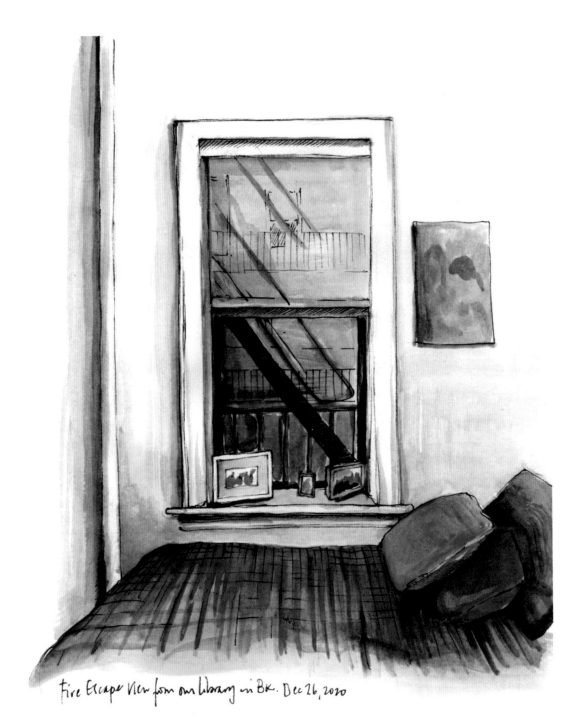

Fire Escape View from our Library in BK. Dec 26, 2020

INDEX

A
abstract works, 104, 122, 125, 128, 151–52, 159
acrylic gouache, 19, 163
art museums, 64–65

B
balance, 46–47
blind contour drawings, 33–37
brushes, 16, 163

C
calligraphy, 70
cast shadow, 40
circles, making, 29
Civardi, Giovanni, 2
color, drawing with, 79–85
colored pencils, 20–21
composition, 87–92
continuous line drawings, 33–37
core shadow, 40
crosshatching, 74, 75, 77, 78

D
drawing
 with color, 79–85
 emotions and, 2, 97, 104, 160–61
 first lesson for, 27–31
 from life, 63, 64–65, 68
 as meditation, 1, 4
 from memory, 63, 68
 as muscle-memory skill, 7, 63
 preserving memories with, 97–101
 progress and, 160
 from reference, 63, 66–67, 68

seeing and, 2, 5–7
warm-up exercises for, 29

E
erasers, 14
everyday life, 143–49
experimenting, 151–54, 156–59

F
flowers, 121–22, 125, 127–28
food, 146, 148
foreshortening, 52
future, drawing, 103, 106–7

G
Gaudi, Antoni, 121
gouache, 19, 81–82
granulation, 80

H
handwriting, 70–71
highlights, 40, 84
horizon lines, 90

I
ink, 15, 73–78

L
leaves, 122, 125, 128
lettering, 70–71
life, drawing from, 63, 64–65, 68
light and shadow, 39–43
lines, making, 29

Merrill Lake Sanctuary walk twice in one day Dec. 27, 2020

Published in the United States by Watson-Guptill Publications, an imprint of
Random House, a division of Penguin Random House LLC, New York.
www.watsonguptill.com

WATSON-GUPTILL and the HORSE HEAD colophon are registered trademarks of
Penguin Random House LLC.

Library of Congress Cataloging-in-Publication Data
 Names: Baker, Samantha Dion, author.
 Title: Draw your world : how to sketch and paint your remarkable life / by
 Samantha Dion Baker.
 Description: First edition. | California ; New York : Watson-Guptill,
 [2021] | Includes index.
 Identifiers: LCCN 2020035234 (print) | LCCN 2020035235 (ebook) |
 ISBN 9781984858207 (trade paperback) | ISBN 9781984858214 (ebook)
 Subjects: LCSH: Drawing—Technique.
 Classification: LCC NC730 .B25 2021 (print) | LCC NC730 (ebook) |
 DDC 741.2—dc23
 LC record available at https://lccn.loc.gov/2020035234
 LC ebook record available at https://lccn.loc.gov/2020035235

Trade Paperback ISBN: 978-1-9848-5820-7
eBook ISBN: 978-1-9848-5821-4

Printed in China

Acquiring editor: Kaitlin Ketchum
Project editor: Ashley Pierce
Designer: Lisa Schneller Bieser
Production manager: Jane Chinn
Copyeditors: Mark Burstein and Rachel Markowitz
Proofreader: Carol Burrell
Indexer: Ken DellaPenta
Marketer: Andrea Portanova

10 9 8 7 6 5 4

First Edition

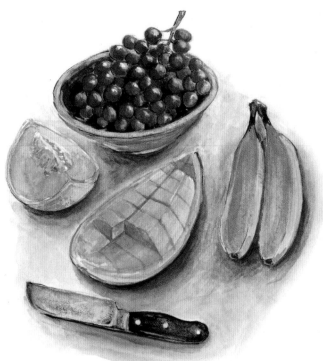